MORETON-IN-MARSH

THROUGH TIME

Mark Turner

AMBERLEY

First published 2018

Amberley Publishing
The Hill, Stroud, Gloucestershire, GL5 4EP
www.amberley-books.com

Copyright © Mark Turner, 2018

The right of Mark Turner to be identified as the
Author of this work has been asserted in accordance with
the Copyrights, Designs and Patents Act 1988.

ISBN 978 1 4456 8427 7 (print)
ISBN 978 1 4456 8428 4 (ebook)

British Library Cataloguing in Publication Data.
A catalogue record for this book is available from the
British Library.

Origination by Amberley Publishing.
Printed in Great Britain.

Introduction

Moreton-in-Marsh is a popular tourist destination in Gloucestershire's picturesque North Cotswolds district. The northern gateway to the Cotswolds, it features in many guides and websites, and for a fairly small town is very well known – helped, no doubt, by its name's association with the BBC comedy radio show *Much-Binding-in-the-Marsh*. This aired from 1944 to 1954, two of its stars – Kenneth Horne and Richard Murdoch – having served at RAF Moreton-in-Marsh as flying instructors. More recently, from 2013, the town has been regularly used as one of the filming locations for the BBC's *Father Brown* television series.

The origin of town's name has long been debated. In Victorian times there were two schools of thought. One group said that 'in Marsh' derived from 'hen mearc', meaning 'on the boundary'. The second group contested that the name meant what it said, pointing out that much of the land around Moreton was marshy and prone to flooding. In the thirteenth century the marshy heathland around the area was known as the 'Hennemerse', and the 'haunt of wild fowl', with the town's name at one time being Moreton in Henmarsh, before reaching its present name. The inaccurate variation Moreton in *the* Marsh, coined by the nineteenth-century railway companies, never achieved widespread usage.

The place has a long history, however. More than two million years ago, as the climate warmed following the Ice Age, the ground upon which Moreton-in-Marsh stands would have been on the southern shore of a huge lake – known to geologists as Lake Harrison – that covered most of what is now Warwickshire. The teeth of mammoths have been found in the area, indicating the presence of these beasts during this period, although the recent discovery of Stone Age hand axes used by Neanderthal man around 100,000 years ago provides the earliest evidence of human activity in Moreton. Early in the present century, a Bronze Age farmstead of the second millennium BC was discovered on ground at Blenheim Farm, while earthworks on the Batsford Road are from the Iron Age. Following their invasion of Britain in AD 43, the Romans completed construction of the Fosse Way by the middle of the first century AD – the original Roman road lying a few feet below the present surface of the High Street.

The earliest form of Moreton as we see it today was created by the Saxons in the sixth century AD. By the eleventh century the town was the property of Westminster Abbey and from 1222 to 1226 the abbot began developing Moreton as a market town, creating the wide High Street for this purpose. In 1226 Henry III granted a charter for a weekly market to be held in the town and it is still held every Tuesday. The town has for centuries been largely agricultural, and sheep provided a significant source of income in the Middle Ages.

Two interesting features of the sixteenth and seventeenth centuries can still be seen: Curfew Tower, at the junction of High Street and Oxford Street, was probably built in the sixteenth century; and Campion House (formerly University Farm), in the High Street and opposite the Manor House Hotel, has an interesting doorway with a frieze and cornice and is dated 1678. The town began to develop further in the seventeenth and eighteenth centuries with the establishment of minor industries and the arrival of the railway. Modernisation continued apace after the two world wars and Moreton has for some time been one of the principal growth areas of the North Cotswolds.

Fortunately, many old photographs of Moreton-in-Marsh have survived to present an evocative record of the town's changing face. A large proportion of the photographs in this book are taken from the author's extensive personal collection – accumulated over several decades – and from the collection of the late Reg Drury. Numerous other individuals kindly loaned or donated photographs for use by the author. Grateful thanks is expressed to everyone who helped in this respect and, in particular, to Derek Barkes, whose work on improving, copying and printing the photographs has been invaluable.

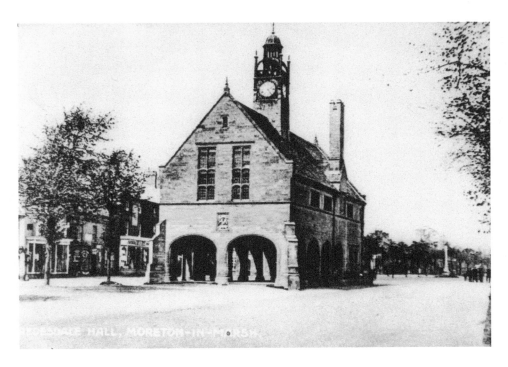

The Redesdale Hall

A prominent focal point on the town's wide High Street, the Redesdale Hall, pictured in the 1920s, was built in 1887 to mark Queen Victoria's diamond jubilee, using stone from nearby Bourton-on-the-Hill quarries. In 1952 its arches were filled-in to enable wider use of the building. It gained a place in the annals of rock 'n' roll history when in 1973 it was used by Elton John for the launch of his Rocket Records label.

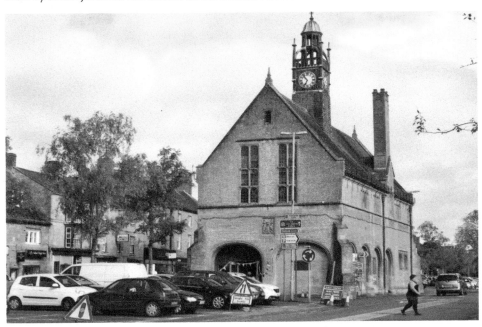

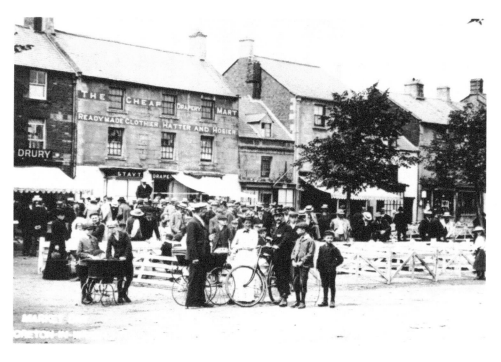

The Market, High Street

Operating under a charter granted by Henry III in 1226, the town's market was held in the High Street until 1923 when it moved to Station Road, where it ran until 1956. It then lapsed until 1976, and then recommenced (without livestock) in the High Street, where it continues to this day. In this early twentieth-century view, shops in the background include Arthur Drury (butcher), Charles Stayt (draper) and Joe Emes (hairdresser).

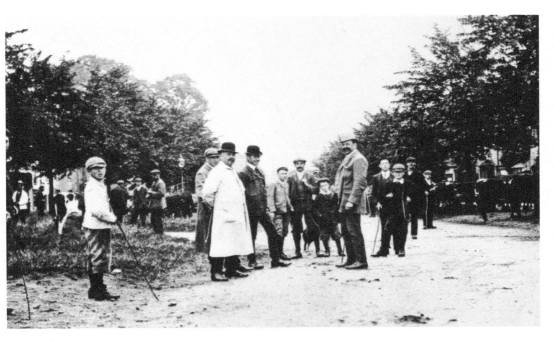

High Street on Market Day

The market auctioneer and others on the High Street opposite the New Road junction in 1909. Sheep were enclosed behind wooden hurdles in the High Street, with cattle usually tied to the trees that lined the road, while pigs were sold on ground known as 'pig alley', at the back of The Redesdale Arms Hotel. Poultry and dairy products were sold from a roadside area to the front of The White Hart Royal Hotel.

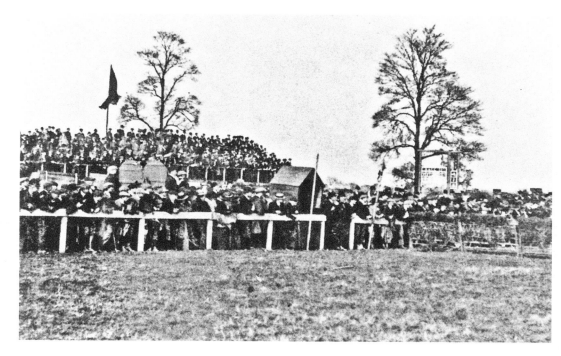

The Racecourse, Stow Road

Until its closure in 1915, Moreton-in-Marsh racecourse ran over fields between Dunstall Farm and Frogmore Farm, around a mile to the south of the town. It is known to have been operating in 1857, but may well have opened as early as the 1840s and was very well attended, as this 1909 photograph illustrates. Today there is no trace of the course and the ground has recently been earmarked for housing development.

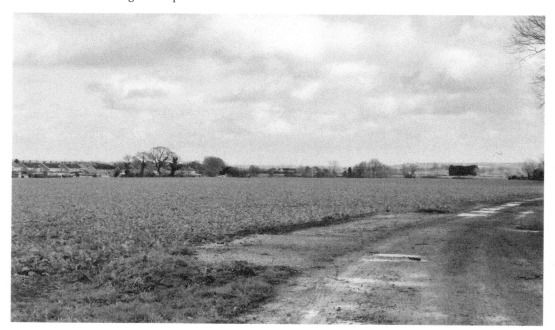

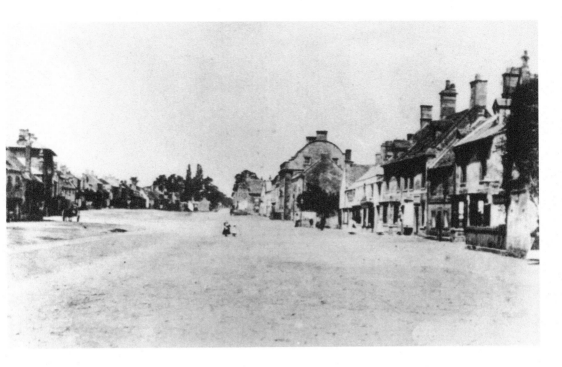

High Street Looking North

The long and broad High Street photographed in 1864, twenty-three years before the building of the Redesdale Hall in 1887. The tall building on the left is the Old Bank, built around 1840 and remodelled in 1878 for the Kidderminster and Stourbridge Bank. It later became the Midland Bank, which in 1992 was acquired by HSBC (Hong Kong and Shanghai Banking Corporation). This branch closed in 2017.

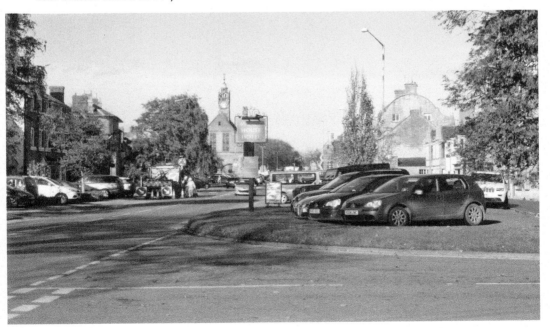

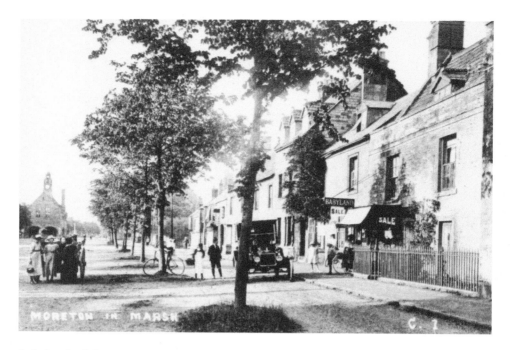

Babyland, High Street

Now part of the Manor House Hotel, this building was in the early 1920s owned by local solicitor Hubert Challen Sharp, who named it Creswyke House after a wealthy Bristol merchant family who had lived there from the seventeenth century and owned much local land. His wife opened the Babyland clothes shop in 1920. The house, with its two-storey gabled entrance porch dated 1658, became The Manor House Hotel shortly before the outbreak of the Second World War.

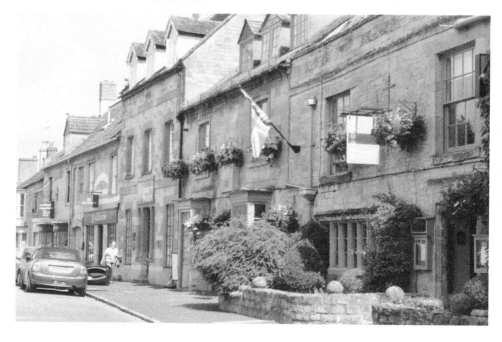

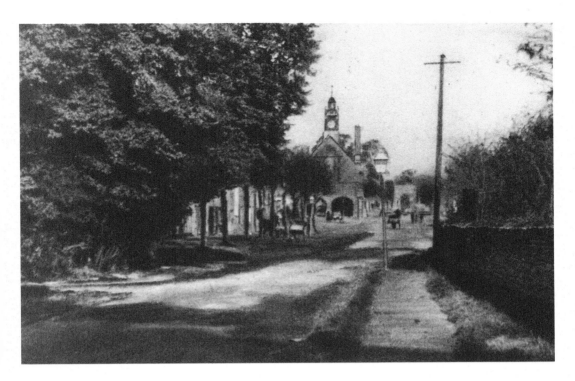

High Street, Past Parkers Lane

Looking north along the High Street, close to its junction with Parkers Lane, around 1915. The large tree on the left has long since disappeared and the ground was for many years occupied by a Gospel Hall, but part of the University Farm retirement complex was built on the site in the early years of the twenty-first century.

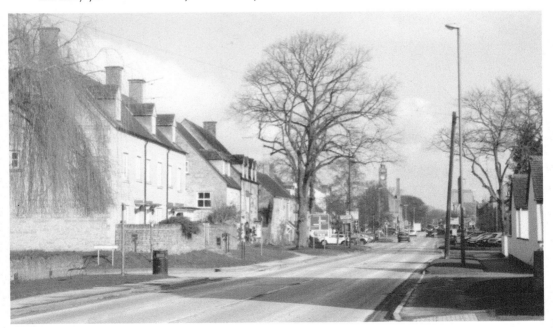

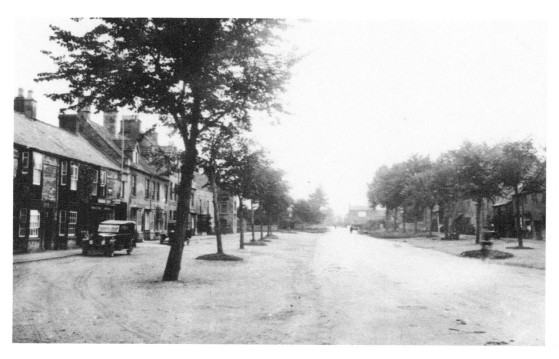

Horne's Grocery Shop, High Street

Horne's grocery wholesale shop, which opened in 1811, is seen on the left in this 1930s view. In 2018 the former shop was occupied by the Sitara restaurant. The White Horse public house, with its prominent white sign on the wall, can be seen in the far distance. The pub's name changed to the Inn on the Marsh in 1992.

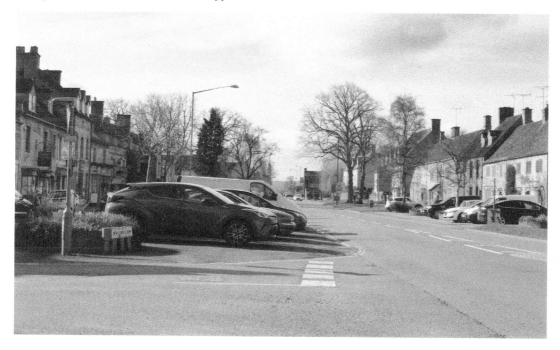

Dunstall House, Stow Road

Opened in 1963 as a warden-controlled development of 'flatlets' for the elderly, Dunstall House was in the mid-1980s converted into a series of self-contained flats for rental, with the town's library moving into the south-western section of the building. A number of the flats were seriously damaged when a major fire broke out there in the early hours of Christmas Day 1999, although thankfully no one was injured.

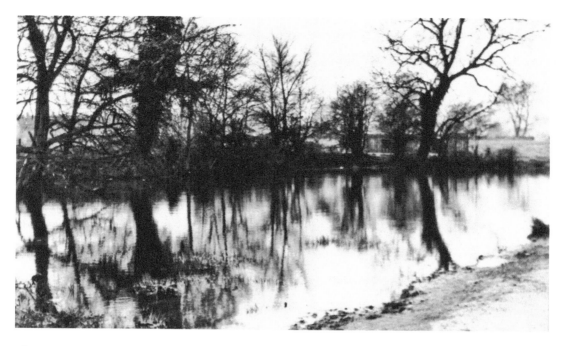

The Horse Pool, Parkers Lane

Nowadays home to a population of ducks, the pool shown in this 1951 photograph has through the years been used by horses, cattle, tanks on manoeuvres and elephants from a visiting circus. It was the scene of a drowning in 1916 when a local man fell into it and in 1956 it survived a proposal to fill it in and build upon it. The surrounding stone wall was built in 1987 by Mr Stan Janus.

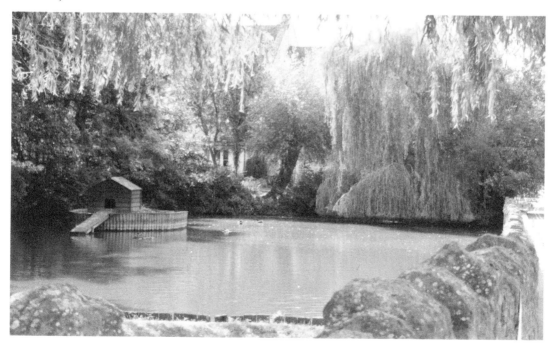

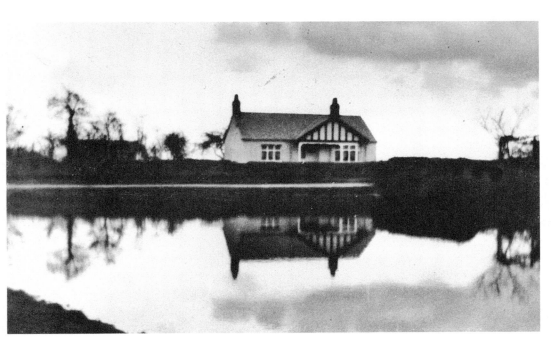

The Horse Pool in Flood

The Horse Pool flooded across the Stow Road in the 1930s. The bungalow, called Caerphilly, was built in 1924 and was in the early twenty-first century demolished to make way for Walnut Close, which was built in 2003. The ground to the left was taken up with George Smith's garden ornament display in the 1930s, but by the 1980s was occupied by Stefan Law's car sales. Stonefern Court was built there in 1986.

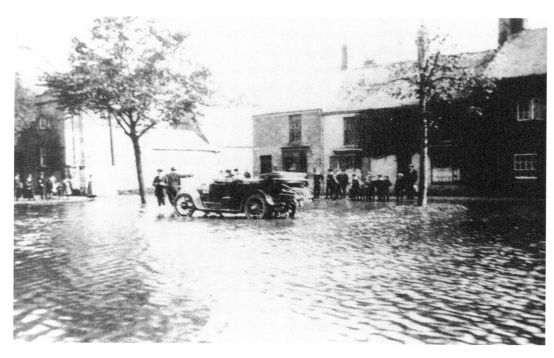

High Street in Flood

Moreton-in-Marsh was seriously flooded in 2007, but had years earlier been prone to fairly regular flooding. This photograph of around 1915 shows the water covering the High Street, across to East Street. Floodwater would flow down Bourton Road, past (and through) the Swan Inn and down East Street.

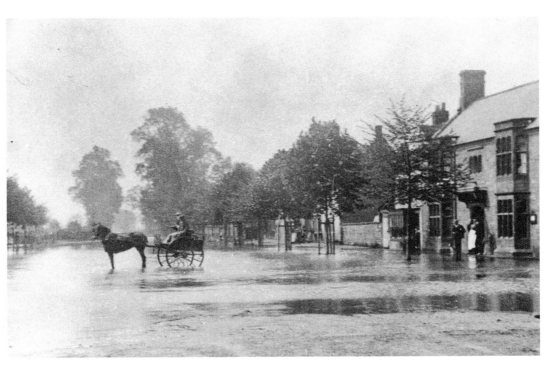

High Street in Flood

The south end of the High Street, near the Swan Inn, flooded in the early 1900s. Raised wooden walkways on trolley wheels were often utilised to enable pedestrians to get to dry land without getting wet. Horne's grocer's kept a boat for use in the floods.

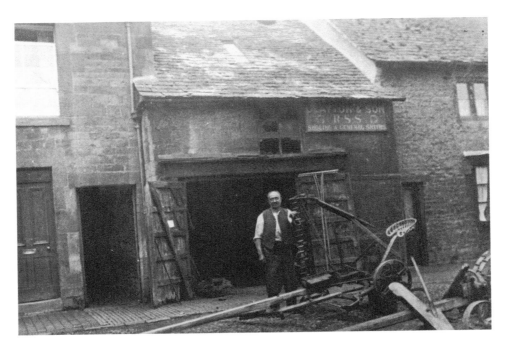

Clayton's Blacksmiths, High Street

Photographed in the late 1920s or early 1930s, Fred Clayton, the blacksmith, is shown at his premises almost opposite what is today The Manor House Hotel. The first record of the family blacksmiths is in 1856 when John Clayton features in Kelly's Directory. In later years Fred's grandson, Alan, ran an agricultural engineering business at University Farm. This was sold in 1988, building on the University Farm retirement complex starting soon after.

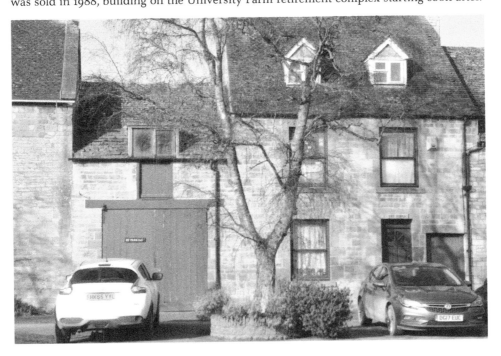

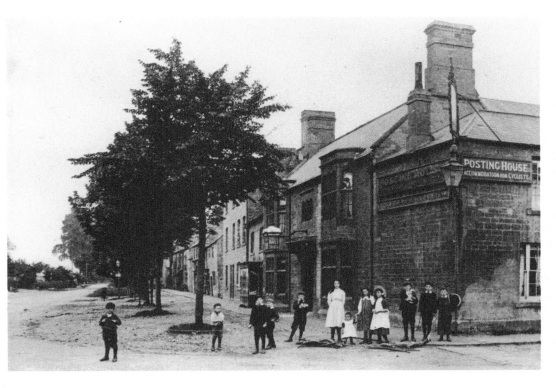

The Swan Inn, High Street

The Swan Inn around 1910. The posting House sign indicates that horses were stabled there for the delivery of mail. The landlord at that time was Frederick Baguley. In 1890 a cycling club was started at the inn. Boxing contests used to take place at the inn's Assembly Rooms in the late 1940s and early 1950s and, by the early 1960s, 'record hops' were regularly enjoyed there by music fans.

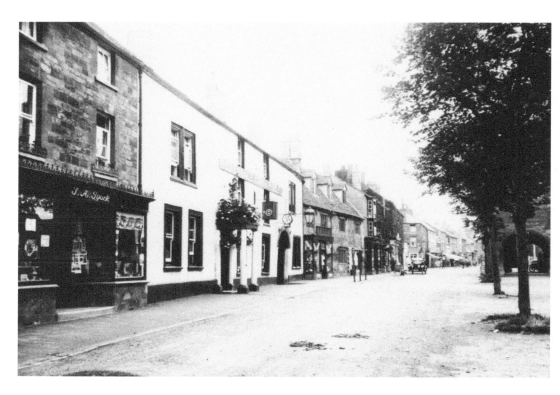

The Redesdale Arms, High Street
A view of Sarah Tyack's stationery shop and the Redesdale Arms Hotel in the 1930s. The shop later became a dwelling house, recently becoming a shop again. The hotel, which was known as The Unicorn until 1891, is mainly of the late nineteenth century, although parts of the building are claimed to date to 1650.

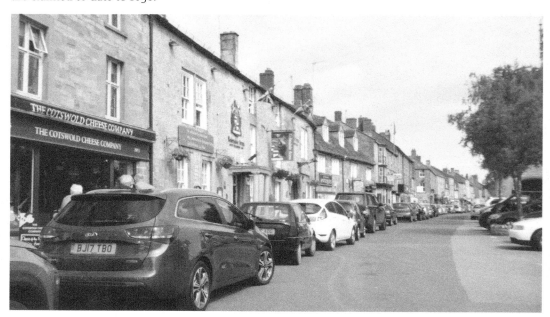

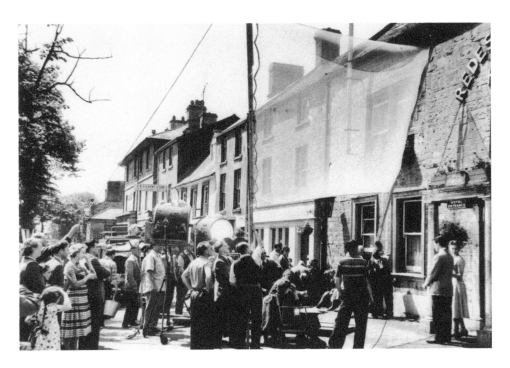

'Now and Forever'

The Redesdale Arms Hotel was used as a filming location for the 1956 romantic drama movie *Now and Forever*, starring Janette Scott and Vernon Gray – seen in the entrance on the right of the photograph. The hotel dining room features prominently while the couple take breakfast before visiting the neighbouring jeweller's shop (now Kevin Tait's opticians practice).

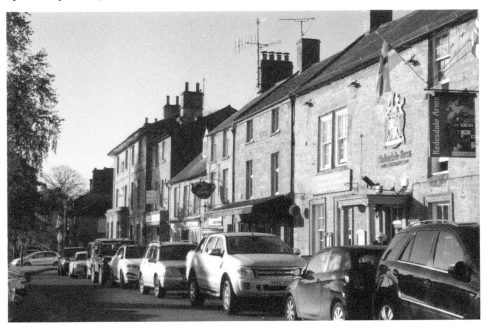

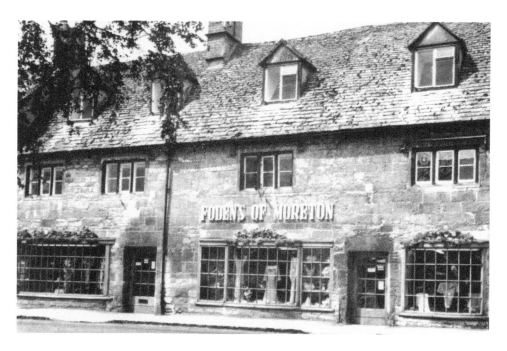

Foden's Drapers

A photograph of Foden's drapers' shop on the west side of the High Street in 1954 when the oak doors and bow windows were installed. Originally consisting of three separate houses, the business opened in the early 1880s, going on to become one of the town's premier clothing shops for many years. William and Annie Spearing became the proprietors in 1931. The shop finally closed in 1973.

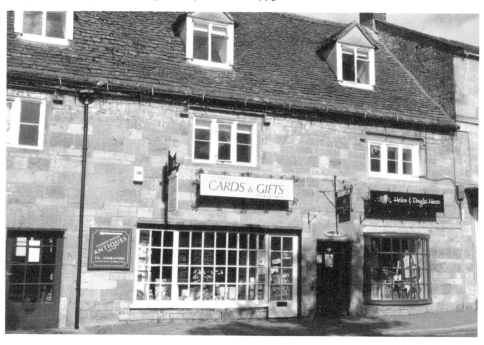

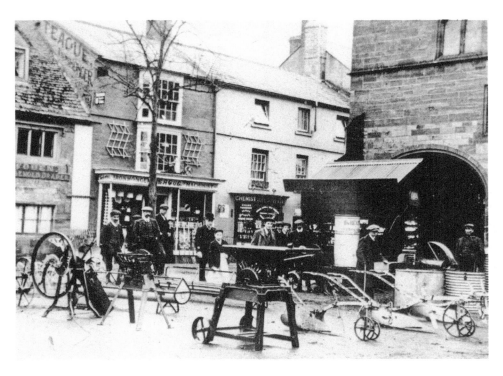

Teague's Ironmongers, High Street
Ernest Teague's agricultural ironmongery implements on display outside his shop, probably around 1910–15. Teague's ironmongers business appears in local trade directories from 1879 to 1935. The chemist's shop during this time was run by Joseph Henry Smith.

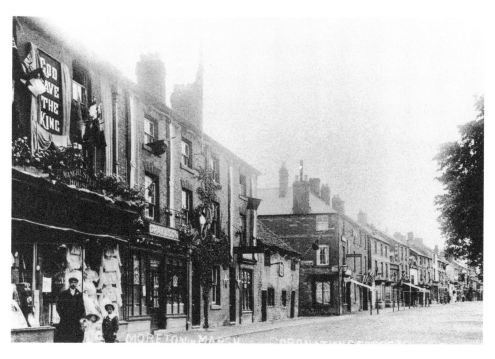

High Street, Towards Corders Lane

High Street decorated for the coronation of George V in 1911. The shops (from left) are Righton and Lewis (draper), Gray & Son (grocer) and a confectionery shop called Clarnico, run by a Mrs Parker. The Spinning Wheel Café was situated in one of the cottages adjacent. This building was later demolished and the Co-operative store built there.

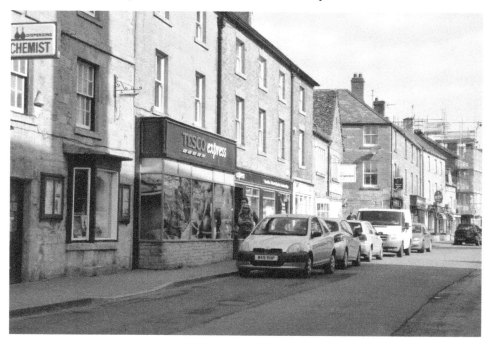

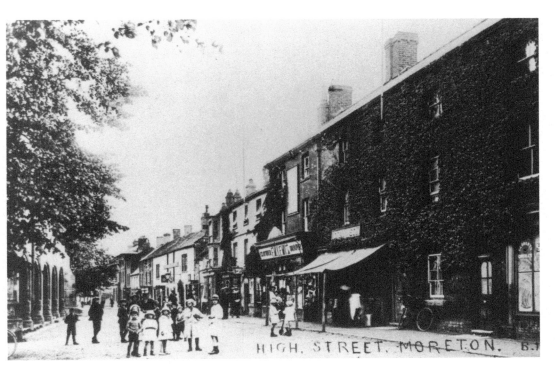

High Street, West Side

Photographed in the early 1920s, the shops (from left to right) are Frederick W. Lewis (draper), Gray & Son (grocer) and Clarnico (confectioner), which was owned by Frank Parker and run by his wife. International Stores took over Frederick Lewis's premises in 1930.

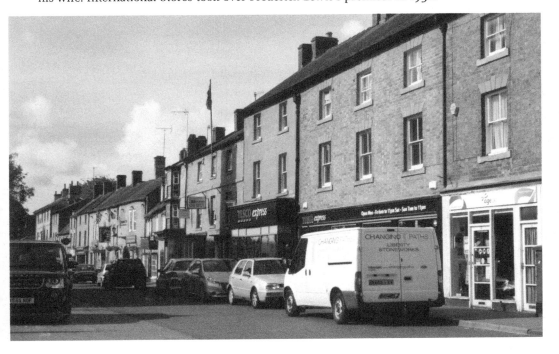

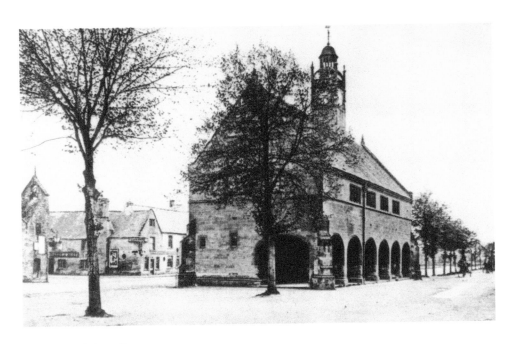

The Redesdale Hall

The fine ground-floor arcade of the Redesdale Hall is prominent in this view of around 1920. The arches were blocked in 1952 to facilitate greater use of the ground floor, although these alterations somewhat spoiled the building's aesthetically pleasing original design. It has been observed by some, however, that when the arcade was open youths would tend to congregate there and that the place often smelt like a latrine.

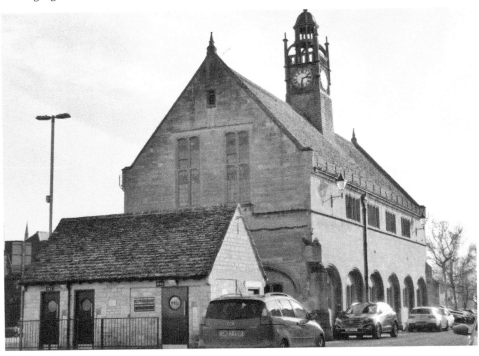

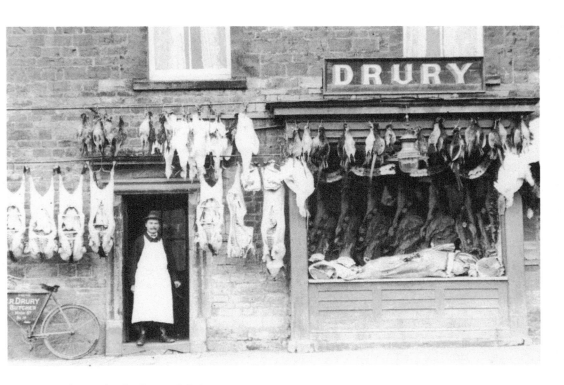

Drury's Butcher's Shop, High Street
The Christmas display at Charles Drury's butcher's shop in 1923. The second oldest business in Moreton (after Horne's grocery), it was founded in 1817 and included a slaughterhouse and yard to the rear of the shop. Reginald Drury, the last of the Drury butchers, retired in 1978. Thereafter, the butcher's shop continued under new ownership until finally closing in 2002.

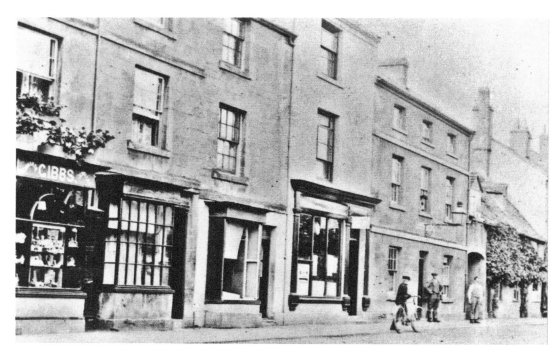

Warner and Gibbs, High Street

In this view taken around 1915–20 the business premises (from left) are Warner and Gibbs (watchmakers), the post office and the Bell Inn (the landlord at the time was Alfred 'Tricky' Taylor). John Warner was listed as a Moreton watchmaker from the late 1830s, although by 1931 the local watchmaker was Raymond Gleed. In 1933 a new post office was built and opened in New Road.

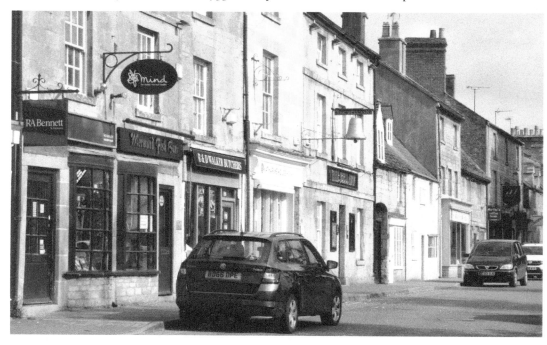

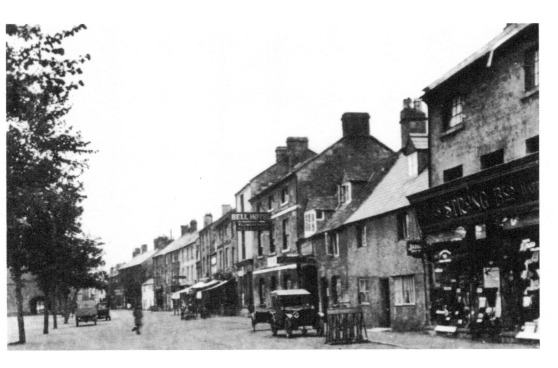

High Street Towards The Bell

A view looking south past Strong's Outfitters towards The Bell (describing itself as a hotel) in 1928. A sign above the archway at the entrance to The Bell's yard states 'garage'. This was run by Bill Fry, who later opened a garage in Station Road.

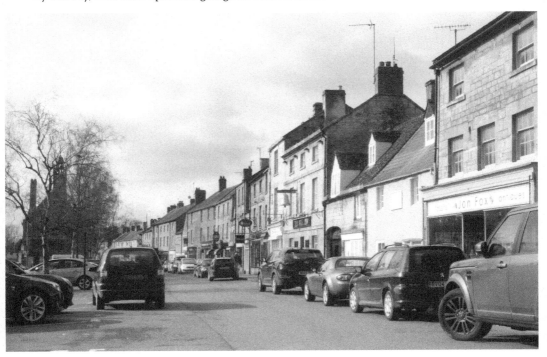

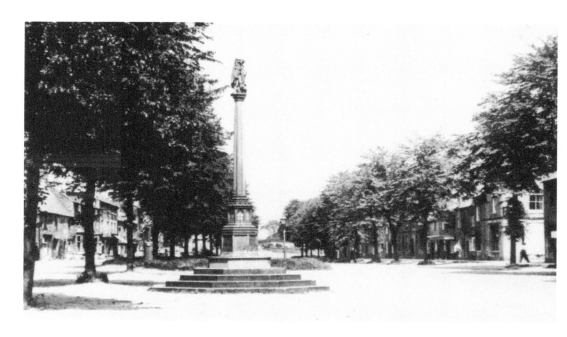

War Memorial

The war memorial photographed in 1939. Designed by Guy Dawber, it was unveiled in 1921 to commemorate the men of Batsford and Moreton-in-Marsh who died in the First World War. Built of Hollington stone from Derbyshire, it stands 24 feet high on a flight of five steps, with the names of the fallen inscribed on five panels at the monument's base. The figure of St George slaying the dragon stands at the top of the monument.

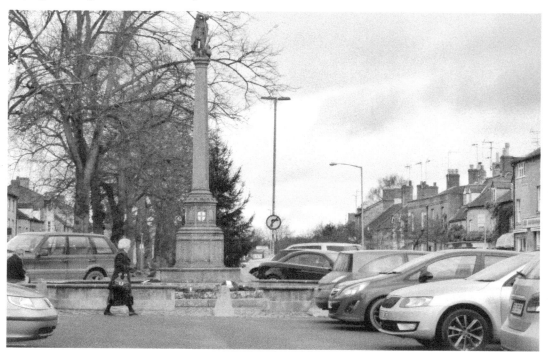

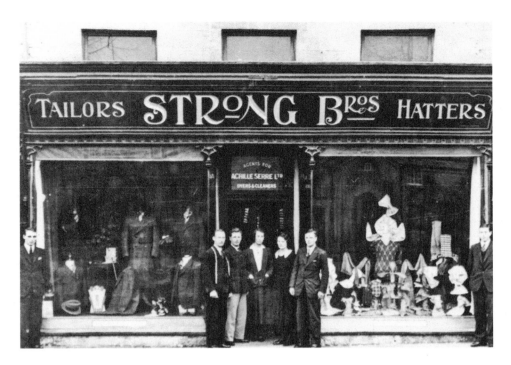

Strong's Outfitters, High Street
Established in 1887, Strong Bros was a high-quality outfitters' shop throughout its existence, once employing around eighteen tailors – who would sew as they sat cross-legged on the floor of a workshop on the premises – when this photograph was taken in 1933. The business closed in 1997.

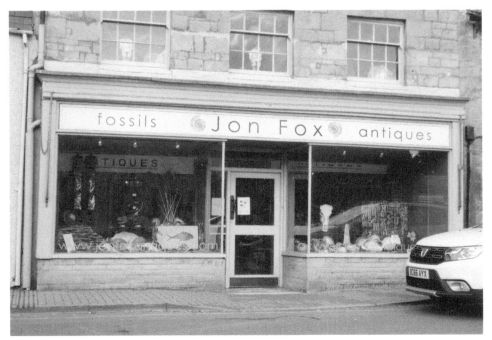

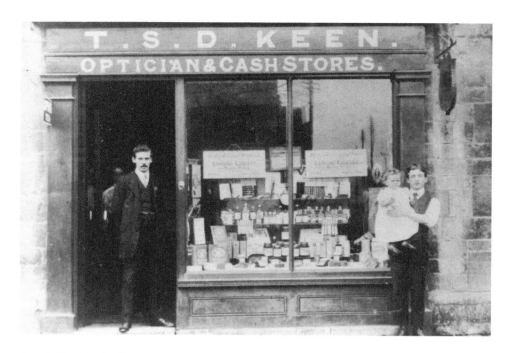

Keen's Optician's Shop

Theodore Stanley Dammerell Keen ran this pharmacy and opticians shop in the High Street at premises that much later formed part of Ben Jeffrey's ironmonger's store – preceded by ironmongers Percy Sheen, and then Stanley Wass – and, for a time, Threshers wine merchant's shop. Keen is listed in Kelly's local trade directory of 1914, but did not appear thereafter, suggesting his practice in Moreton was relatively short-lived.

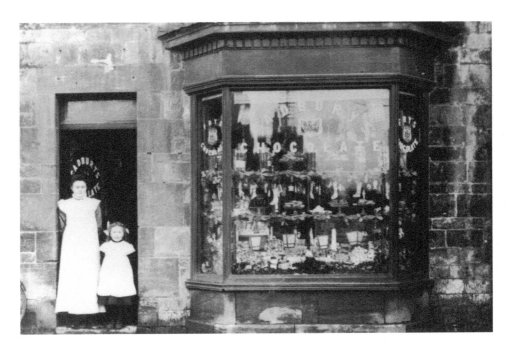

Mace's Confectionery, High Street

Henry Thomas Mace's confectionery and ice-cream shop began appearing in Kelly's local trade directory from 1914 until the last directory dated 1939, although it is known to have continued until the late 1950s. It closed soon after, however, and remained empty and somewhat dilapidated for many years. More recently, it was a travel agent's, and then a floristry for a while, before becoming a rug shop.

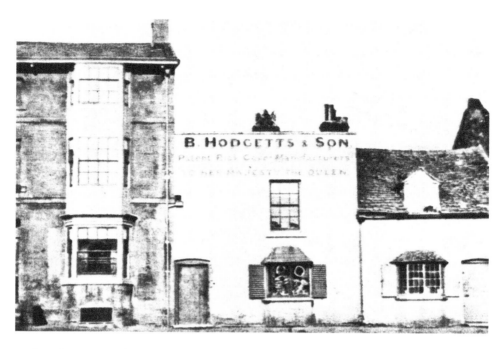

Hodgett's Rope Works, High Street

This rare photograph taken around 1850 shows the large timber and plaster frontage to the rope works founded by Benjamin Hodgetts in 1840. Rope and twine was made by twisting long cords of thread by hand at ropewalks to the rear of the premises, and also at nearby Corders Lane. The business was bought by Thomas Wells in the 1880s, who continued rope making there until his death in 1935.

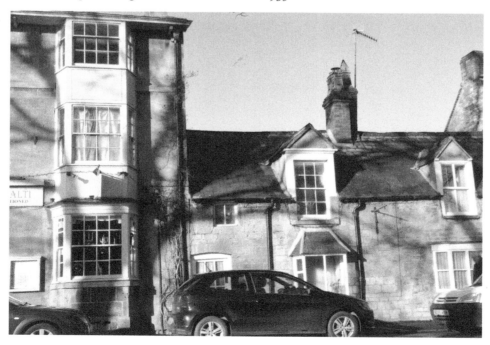

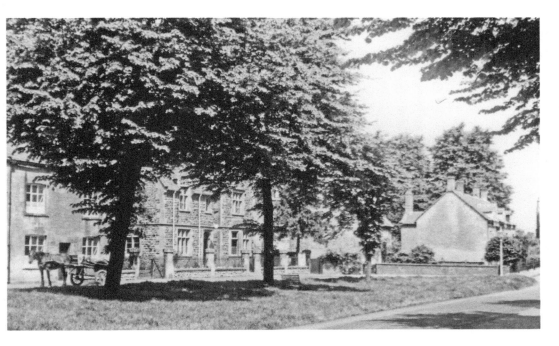

High Street Towards the Police Station

The police station is glimpsed across the greens in this 1930s photograph. The Gloucestershire Constabulary was formed in 1839, Moreton's first police station being on the east side of the High Street at what is now the Cacao Bean café and was for many years Tony Dyer's television shop. In 1897 the police station in the photograph was built, serving the community for well over 100 years. It closed in 2011.

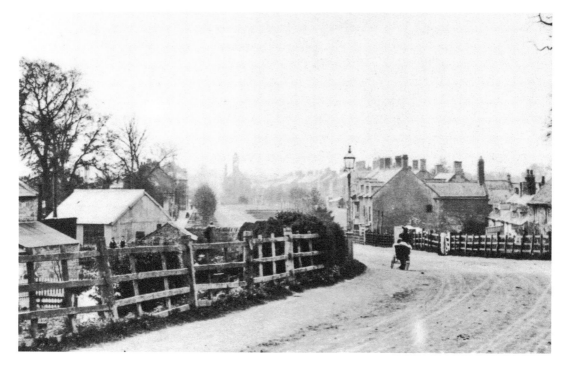

Shipston Bridge

Work on the Oxford to Worcester railway line and its associated infrastructure began in 1845, although the line through Moreton did not open until 1853. This photograph of the Shipston Bridge, which was probably constructed over the line in the late 1840s, was taken in the early 1890s. The building on the left, below the fence, was part of the terminus of the Stratford and Moreton Tramway, which opened in 1826. The building was demolished in 1989.

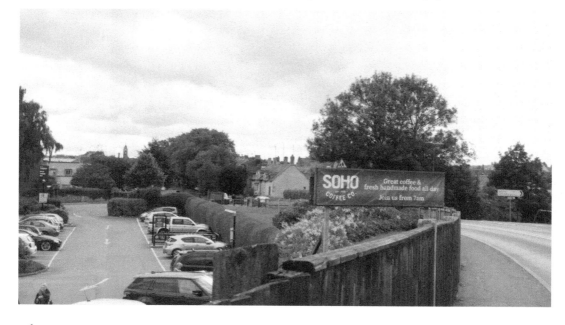

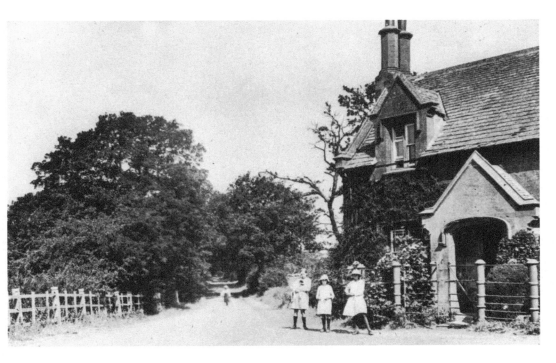

Turnpike Lodge, Batsford Road
Standing at the junction of the Fosse Way and Batsford Road, the Tudor Gothic-style Turnpike Lodge is believed to have been designed by Sir Ernest George in the nineteenth century. The Batsford Road had been turnpiked by 1823 and this was the Batsford gate of the Stow and Moreton United Turnpike Trust.

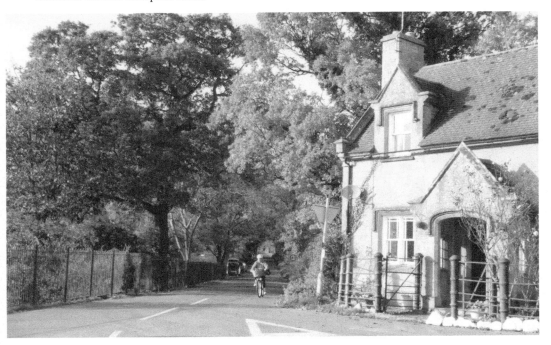

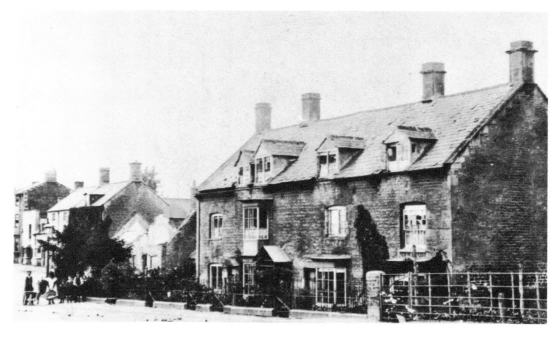

High Street, North End

Dating to the late nineteenth century – and certainly before 1897, when the police station was built – this photograph shows the row of cottages opposite the entrance to Budgens supermarket. The derelict building to the left of the row disappeared long ago and appears to be partly covering ground that the police station was built upon. The frontage to the Rope Works can be seen at the extreme left of the picture.

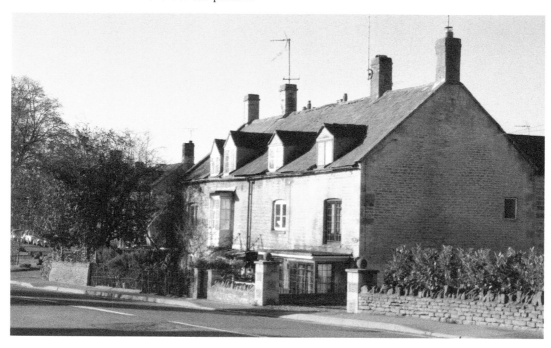

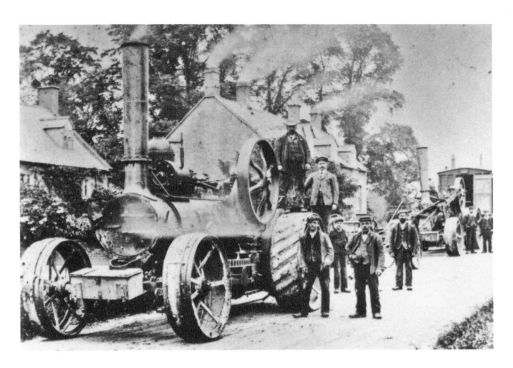

Steam Engines at the North End of High Street

These magnificent steam engines, seen at the north end of the High Street in the late nineteenth or early twentieth century, belonged to Thomas Jeffrey, variously listed as a machinist, steam plough proprietor and thrashing machine hirer in Kelly's local trade directory from 1863 to 1902. Mrs Elizabeth Jeffrey is listed as a steam plough proprietress in the directory for 1906. Local farmers would pay for the use of these machines.

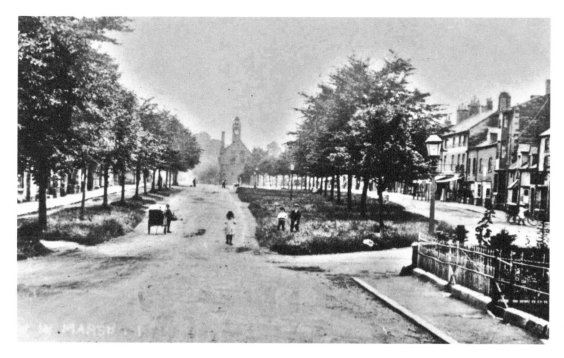

High Street Looking South

In this photograph taken around 1910–15, the rows of lime trees along the verges and greens have become well established since being planted in 1887. The hanging sign of The Foresters Arms is visible on the extreme right of the picture. The pub existed from at least 1859, but closed in 1921, the last licensee being George 'Harry' Smith. The ale was supplied by Charles Gillett's Moreton Brewery, situated in what is today Old Market Way.

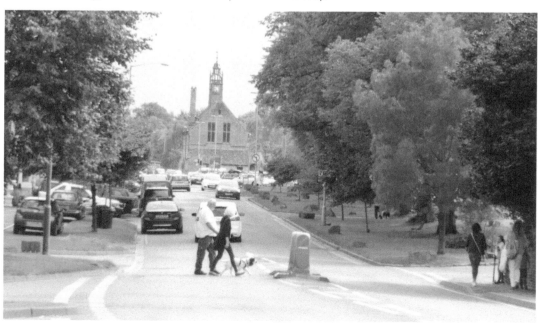

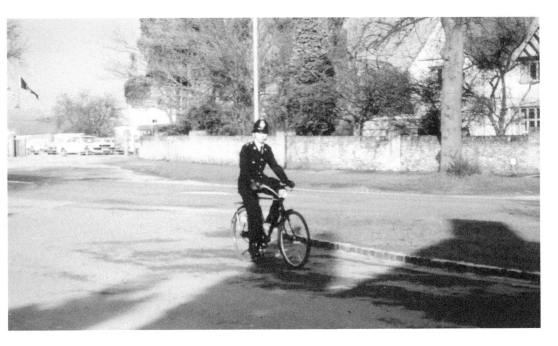

High Street Towards the Grange

Behind PC Turner, pictured around 1981, the former railway yard (housing a market stall erection company) is on the left, while the Grange (formerly the White House, designed by Guy Dawber and built in 1898) is to the right. In 1988 the Grange was demolished and replaced by retirement homes and in 1989 a supermarket was built on the railway yard. The policeman and his bicycle are long retired, and the station has closed.

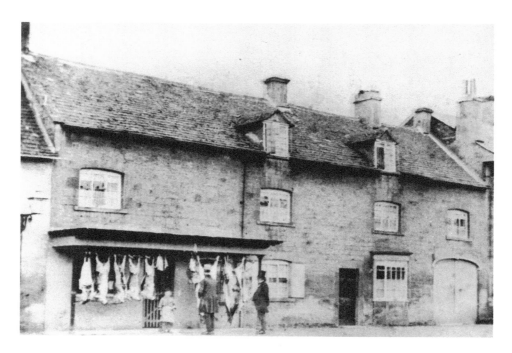

Hollier's Butcher's Shop, High Street

William Hollier's butcher's shop around 1860, which is today occupied by Grimes House Gallery. In 1865 the business was run by Hollier's son, John, who lived with a Miss Gardner and treated her as his wife. She committed suicide when he took another woman as his lover and, hearing of the death, a large mob of townspeople rioted in the town centre, threatening his life and burning an effigy of him. Escaping on horseback after the inquest, however, he survived unscathed.

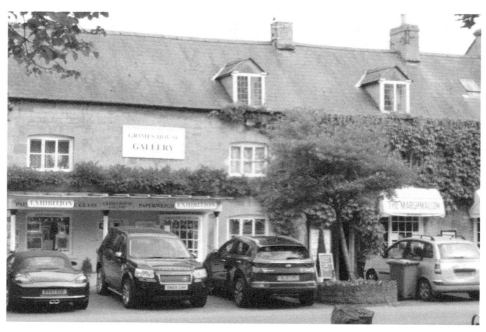

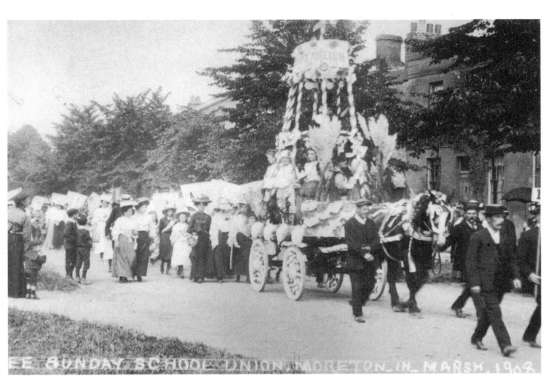

Sunday School Union Parade

This parade in 1908 is pictured at the north end of the High Street near its junction with New Road. Such elaborate parades were fairly regular events at Moreton before the Second World War. A number of annual fêtes featured grand pageants, sporting jamborees and historical re-enactments, with displays in 1923 and 1929 being especially impressive.

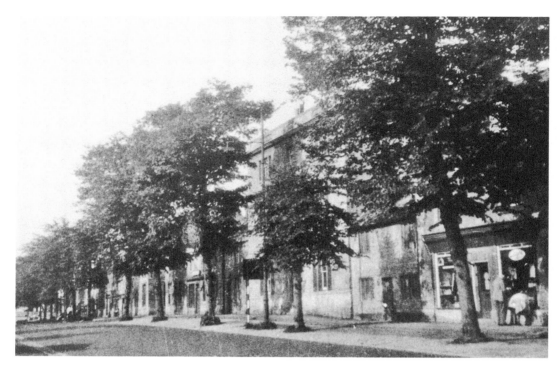

High Street, East Side

Most of the trees in this 1951 photograph were removed in the 1960s and 1970s, having become unsafe. Lloyds Bank is partly concealed in the centre of the picture, with White Lion Cottage adjoining. From the late 1880s to late 1890s the shop on the extreme right was occupied by Moreton Refreshment Rooms. In 1939 the shop sold wireless radios and was run by Ray Gleed, though by 1951 it was owned by Tom Pye.

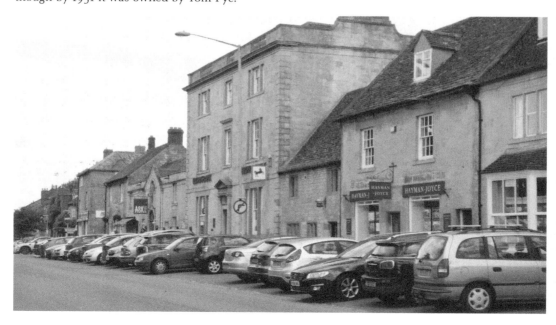

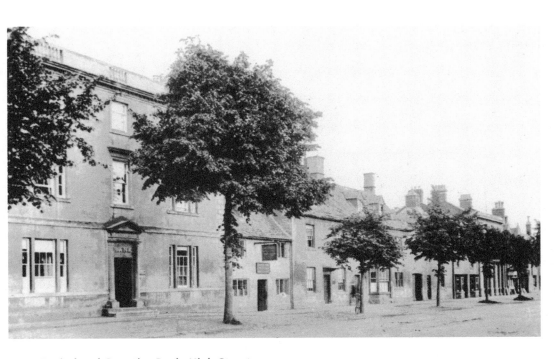

Capital and Counties Bank, High Street

Probably taken near the end of the First World War, this photograph of Capital and Counties Bank – acquired by Lloyds Bank in 1918 – shows the White Lion Inn before it closed around 1919. The bank building is a late eighteenth-century house built of ashlar with quoins and a balustraded parapet, which combine to create a strong and impressive structure.

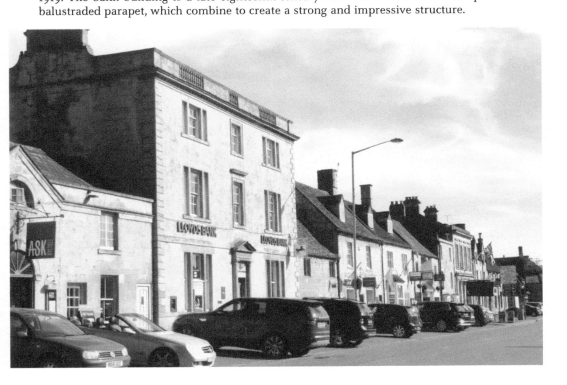

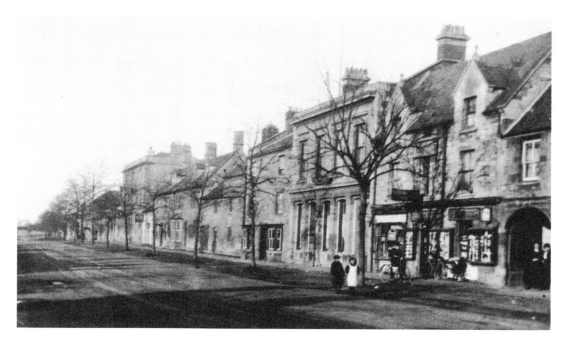

High Street, East Side

A 1918 photograph showing the late nineteenth-century ashlar-fronted building that in 1935 opened as the offices of the North Cotswold Rural District Council (today the District Council's Moreton Area Centre). The pelican crossing was installed in 1978. The archway entrance to the right led through to the Black Bear Inn's yard and out to the former market area. Together with the neighbouring newsagent's shop, the entrance was incorporated into the pub in 1987.

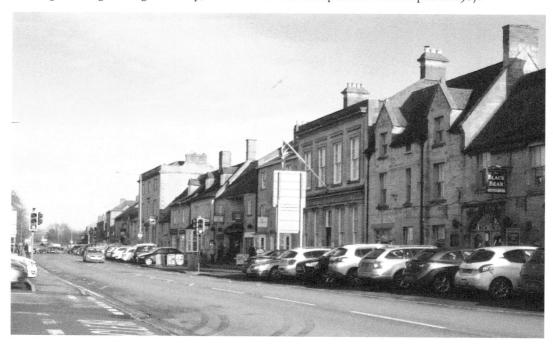

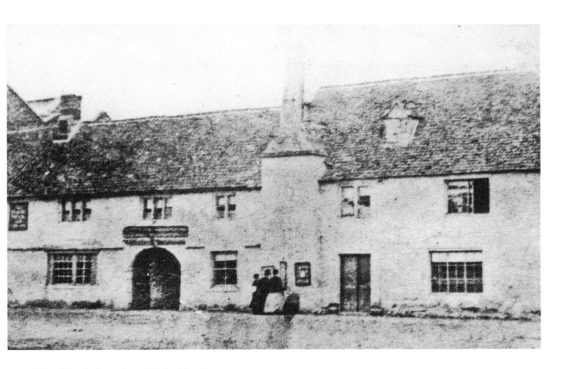

The Black Bear Inn, High Street

This 1869 photograph shows the Black Bear Inn before it was virtually gutted by a major fire in the 1890s. Subsequently reroofed and altered, the vernacular-style building dates to the first quarter of the nineteenth century. The landlord from the 1830s until at least 1870 was James Newman, whose daughter's liaison with local butcher, John Hollier, was a contributory factor leading to the Moreton riot of 1865.

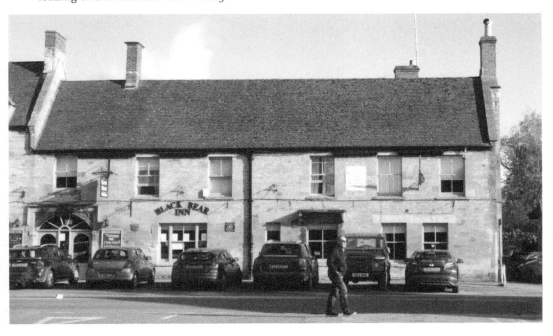

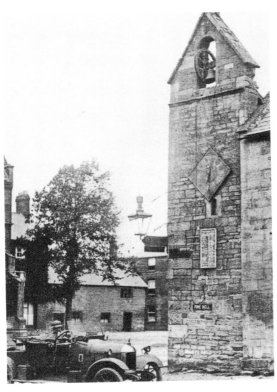

Curfew Tower

Possibly the oldest surviving building in Moreton, the Curfew Tower is believed to date to the sixteenth century. On the tower there is a clock dated 1648 and a bell dated 1633, which was used to ring the curfew until 1860. In medieval times curfews were traditionally rung at around 8 p.m. as a signal for everyone to cover their fires and go to bed. The room at the foot of the tower was used by the parish constable as a lock-up for drunks.

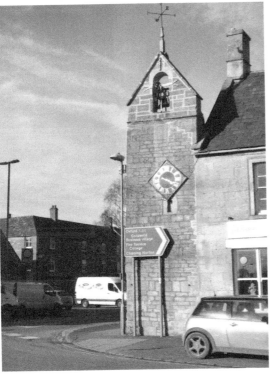

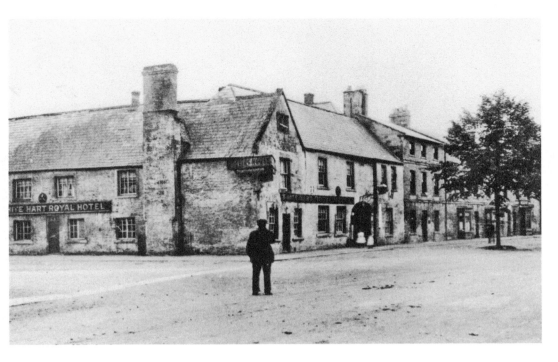

The White Hart Royal Hotel, High Street

Photographed around 1905, this sixteenth-century building was remodelled in the seventeenth and eighteenth centuries. The most ancient part, with the prominent chimney stack, faces Oxford Street. The arched front entrance opens onto a cobbled coachway, leading into Oxford Street. Until the middle of the nineteenth century a wooden sign – depicting a white hart being pursued by a pack of hounds – was suspended across Oxford Street. Charles I spent a night there in 1644.

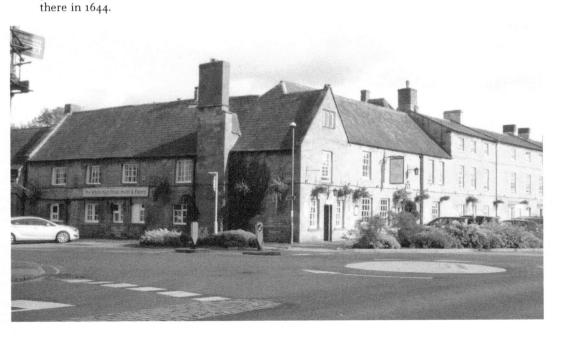

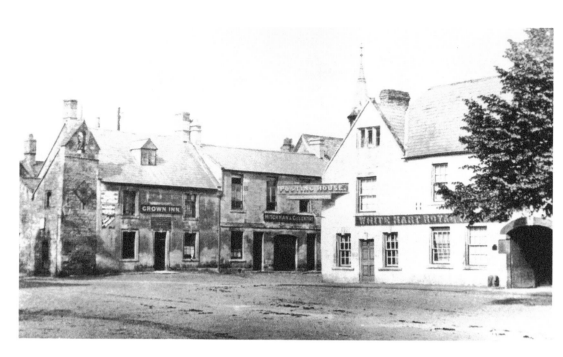

High Street and Oxford Street Junction

Taken around 1910, the White Hart with its coach way entrance and Posting House sign, showing that mail delivery horses were stabled there. The landlord at this time was one John Brown. The Crown Inn, whose landlord was Allan Robert Holbeach, is next to the Curfew Tower in Oxford Street. The Crown closed in 1921. Hitchman and Co., named on the adjacent building, were brewers at Chipping Norton who kept a store in Moreton.

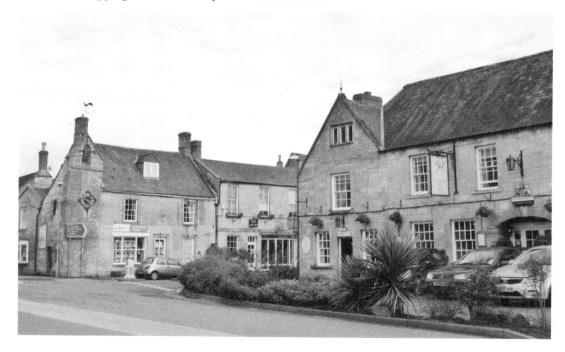

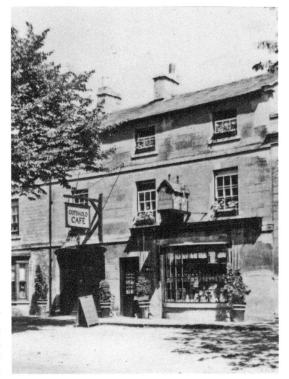

Cotswold Café, High Street

The Cotswold Café, near Horne's grocery shop (now the Corn Exchange), was a well-known refreshment-place in Moreton for decades. From at least the 1930s it was run by Mrs Flora Thomas, who kept it for many years, but by the late 1970s the proprietor had changed and in the 1990s it ceased to be a café. This photograph, believed to be of the 1930s or 1940s, shows the distinctive model cottage at its frontage.

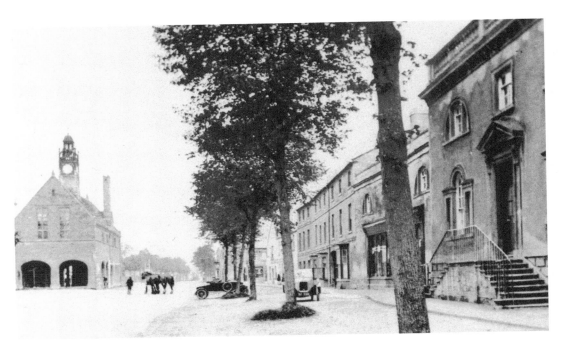

The Steps, High Street

Seen on the right of the photograph, which was taken in the 1920s, is the fine mid-eighteenth-century Palladian town house called The Steps. It has handsome neoclassical features including semicircular windows and a balustraded parapet, its double flight of steps and an iron railing providing amusement to passing children for many years. Horne's grocery shop is seen to the left of the house.

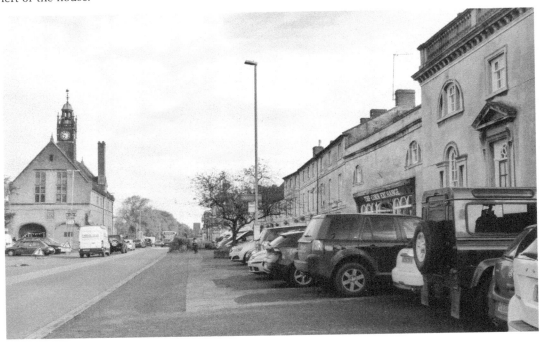

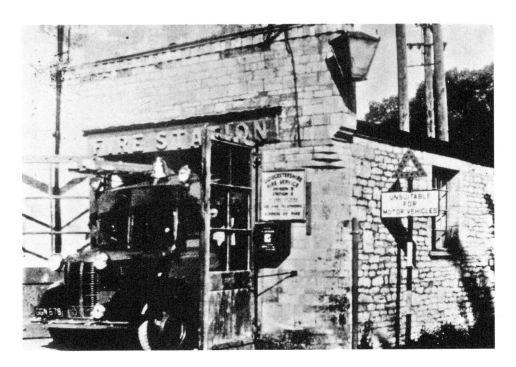

Fire Station, High Street

Pictured in 1954, the fire station – which opened in 1925 – stood where there had once been a pound for stray animals. Earlier, the engine had been stored at Church Street and then in Bourton Road. By the 1960s it was being kept on ground now occupied by Jameson Court, until in 1969 the existing station in Parkers Lane was opened. This 1925 building was later occupied by a children's library and then a voluntary help centre.

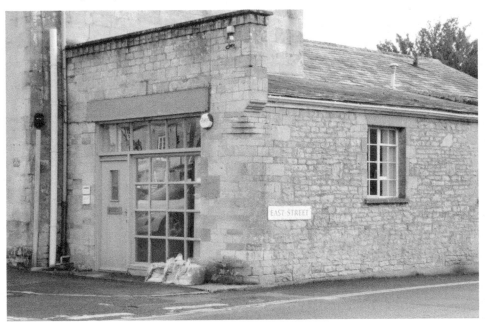

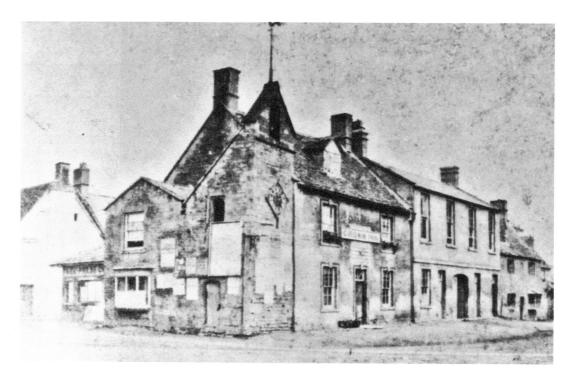

Curfew Tower and Crown Inn

The Curfew Tower and Crown Inn in the 1880s, when Thomas Lamb was landlord. The dilapidated cottages on the extreme right were demolished and in 1891 the Mann Institute was built there. On the left is the office of the Moreton Free Press (now the Sue Ryder shop). The newspaper was published between 1857 and 1895 by Edward James Webb, although in the 1920s the office was occupied by a printer named Charles 'Jack' Hull.

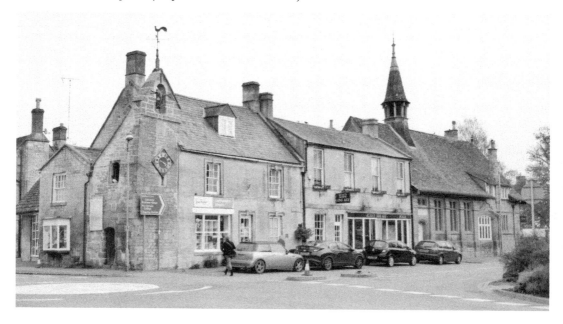

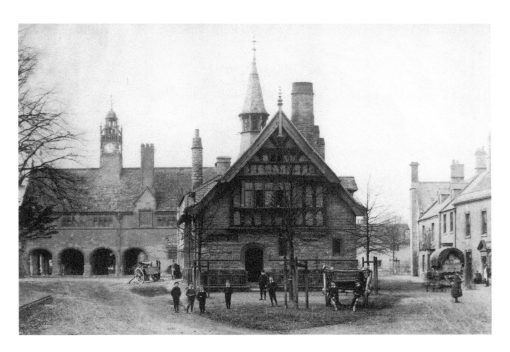

The Mann Institute, Oxford Street

Built in 1891 by Miss Edith Mann in memory of her father, Dr John Mann (son of Revd John Mann, first minister of the Congregational Church), the Mann Institute is shown in 1905. It was originally a working men's club with a large hall, reading room and billiards room. Living rooms upstairs were used in the summer months as short-term holiday accommodation for unfortunate women from London. Brown's bakers shop is on the right.

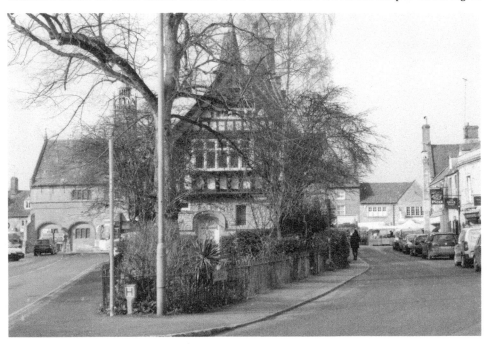

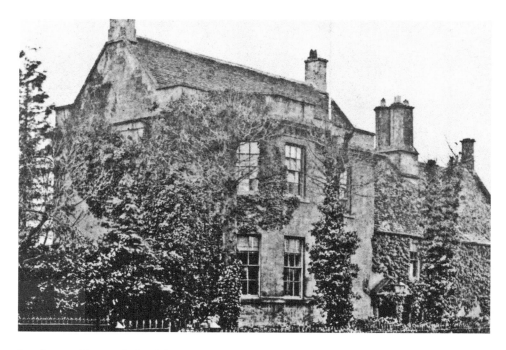

Lemington House, Oxford Street

Taken in the late 1800s or early 1900s, this photograph of Lemington House shows the imposing full-height three-window bays on the left. It was built in the mid- to late seventeenth century, the distinctive façade being added in the 1760s. The west wing (on the right of the picture) is earlier and dates to the early 1600s. Plans in 1977 for it to become a hotel did not come to fruition.

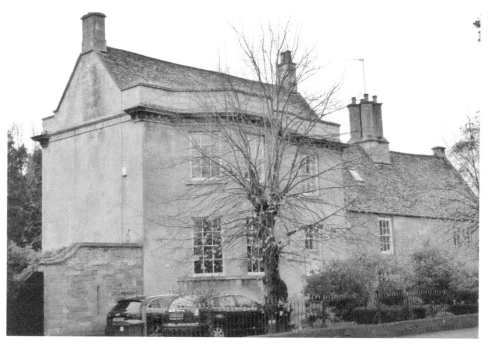

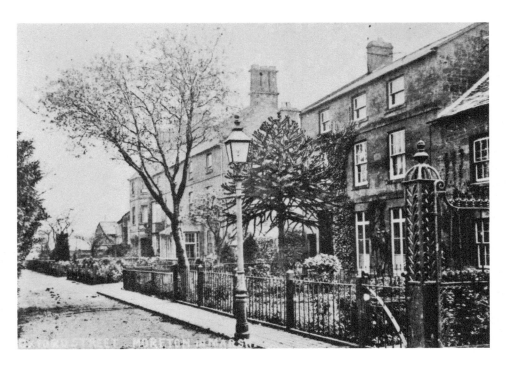

Thurston House, Oxford Street

Oxford Street below the railway bridge embankment and past the entrance to Bengal House, towards the early nineteenth-century Thurston House and The Limes beyond, photographed in the 1920s. The metal railings and ornate gateposts were probably taken down in the 1940s for the war effort. The Star public house, just beyond The Limes, had closed by 1891. Fish and chips were sold by Jimmy Mealin from a black shed by Corner Cottage in the 1920s.

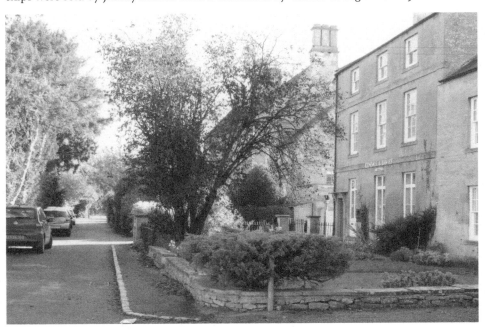

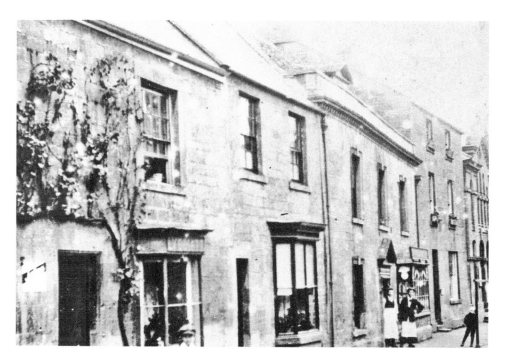

Oxford Street Looking East

Photographed around 1910, two bakers pose outside Michael Brown's bakery (now Artysan), while the shop now known as Henry's of Moreton was at that time occupied by two dressmakers named the Misses Lyddiatt. The building now occupied by The Spice Room and Artysan was in the 1980s a wine bar called The Greedy Grape, which made the headlines when a crazed local man fired a military-grade smoke bomb through the front door!

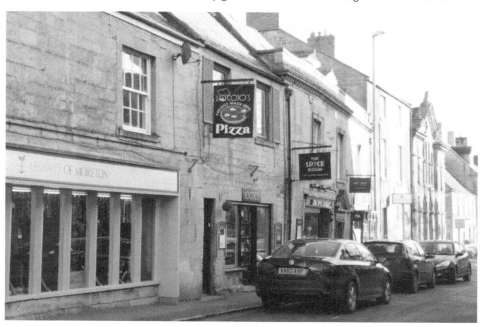

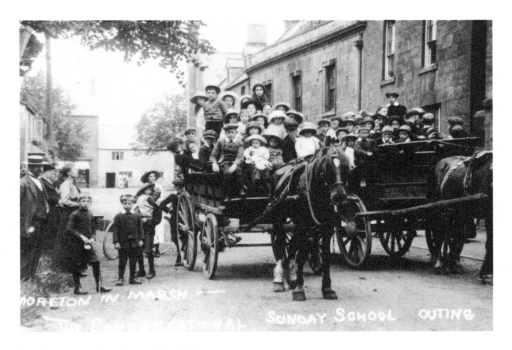

Sunday School Outing, Oxford Street

Children assembled for a Congregational Church Sunday school outing to a local farm around 1910. The Nonconformist church in Moreton started in 1796 when John Mann conducted a service in a barn on ground where the Congregational Church was built in 1860. Oliver Cromwell, on his way from the Battle of Worcester, is said to have taken communion with the Baptists at Moreton in 1651.

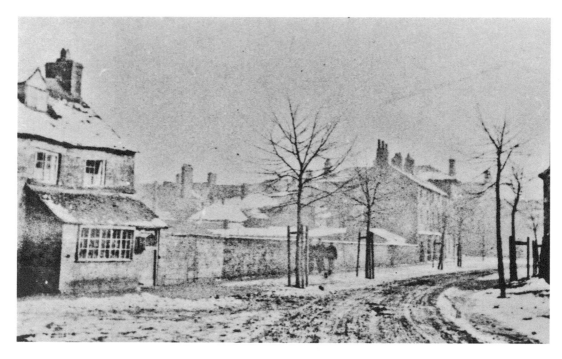

Bourton Road Looking East

Photographed around 1910, the house on the left – now called Three Ways – originally consisted of three small cottages, which converted to a single property in 1939. In the 1930s a lady known as Granny Webb kept a little café in the middle cottage for passing cyclists. West Square – a group of about sixteen very basic dwellings – existed at the back of the cottages until the late 1920s, when they were demolished and the occupants rehoused.

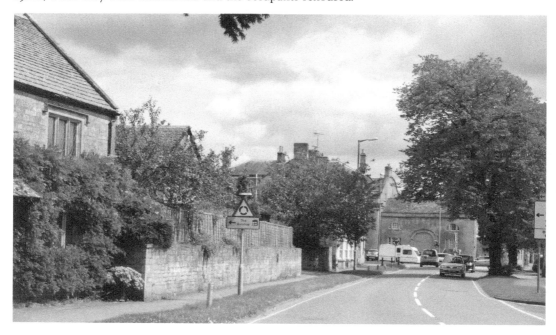

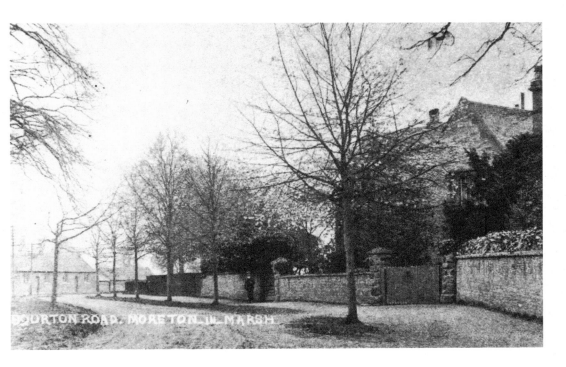

Bourton Road Looking West

Bourton Road, with the Rectory on the right, in 1910. The building on the left is now the Wellington Aviation Gallery. It was built in 1845 as the British School, which taught its 196 pupils in a manner much the same as that at the national school, situated near the church in Old Town. Financial difficulties and a decline in attendance proved impossible to overcome, however, and the British School closed in 1907.

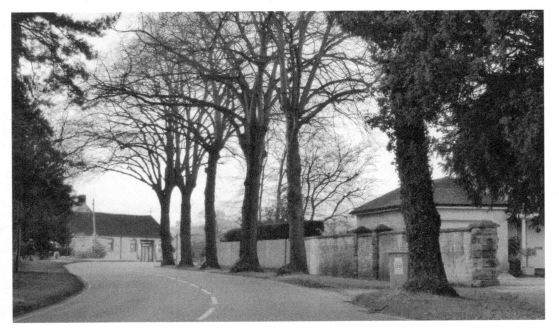

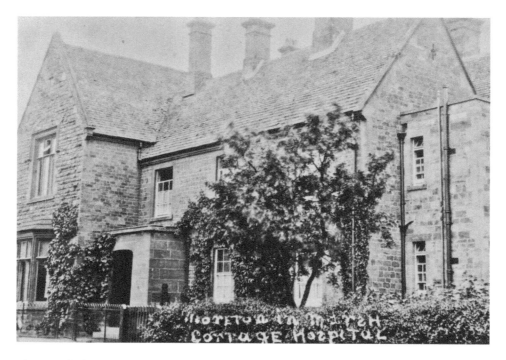

The Hospital, Hospital Road

Opened in 1873, the town's hospital was built on ground at the end of West Street – which became Hospital Road – close to the point where a path crosses the River Evenlode and leads into Queen Victoria's Garden. Seen here around 1915, the hospital was enlarged several times throughout the twentieth century, but closed in 2012 when the new North Cotswolds Hospital was opened at the southern edge of Moreton.

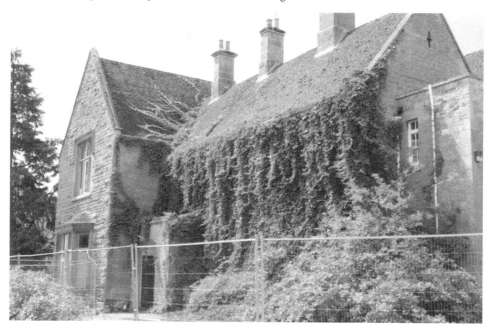

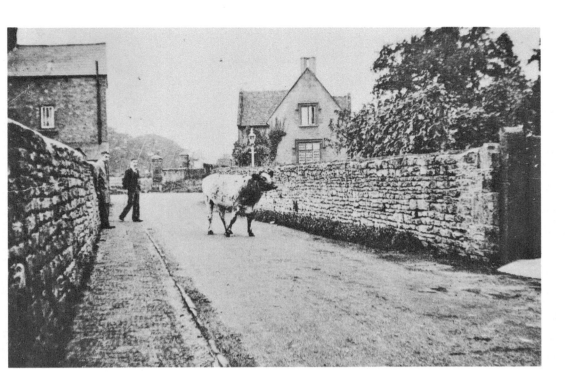

Corders Lane Looking West

In this 1937 photograph an ox is being driven to a slaughter yard at the back of Drury's butcher's shop, where it was to be slaughtered in readiness for an ox roast. Ox roasts were held annually in the High Street through the first half of the twentieth century, the first cuts of meat being auctioned and the proceeds given to the hospital.

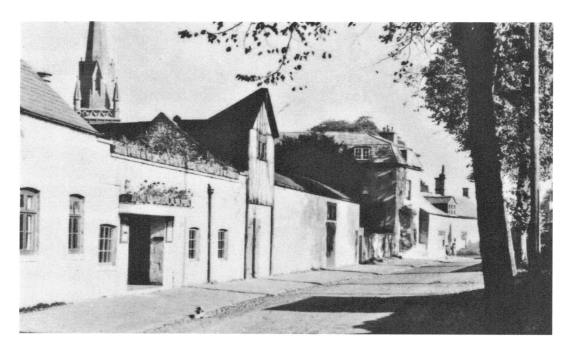

The Cinema, Church Street

The Playhouse Cinema in the late 1950s. The building was a linen-weaving factory from 1742 to around 1880 and was then converted to cottages, which were derelict by the First World War years, being used as an apple store. It became a cinema in 1922, with one of Charlie Chaplin's movies being the first presentation. The cinema closed in 1961, a free showing of *The Spanish Main*, starring Maureen O'Hara, being the final presentation.

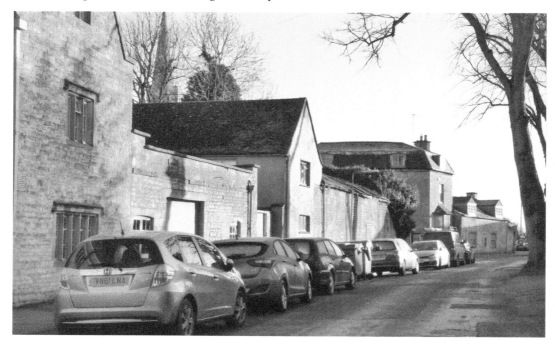

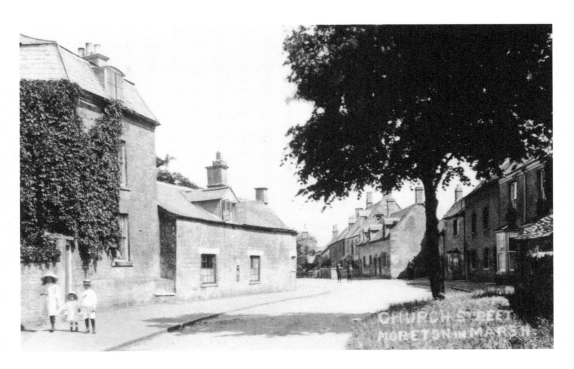

Church Street Looking East

Photographed around 1910–15, the Old Parsonage dates to the early nineteenth century, is partly ashlar faced and has a Mansard roof of Welsh slate. The former coach house attached faces the wrought-iron churchyard gates of 1960. Set into the wall next to the pavement is a Royal Mail postbox of Edward VII's reign. An establishment called the Green Close Beerhouse existed on the opposite side of Church Street for a time in the nineteenth century.

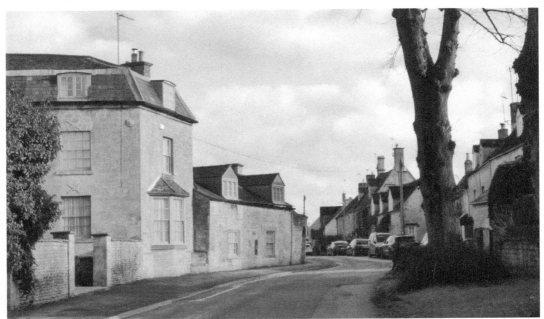

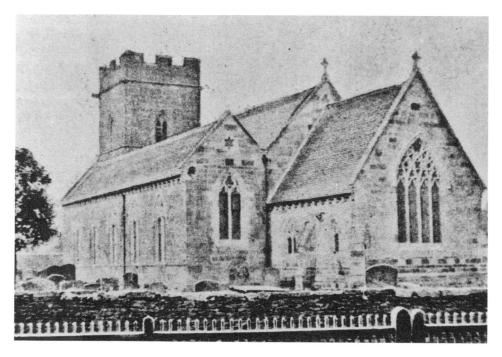

St David's Church

Moreton's medieval St David's Church was almost entirely rebuilt in 1858–59. This rare photograph of around 1860 shows the earlier tower and battlements before a new tower and steeple were constructed in 1860–61. Little survives of the earlier building, although some corbels and a couple of gargoyles have been incorporated into the structure of nearby Orchard Cottage in East Street and are visible under the roof eaves.

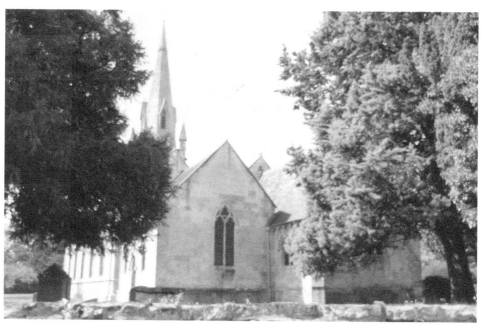

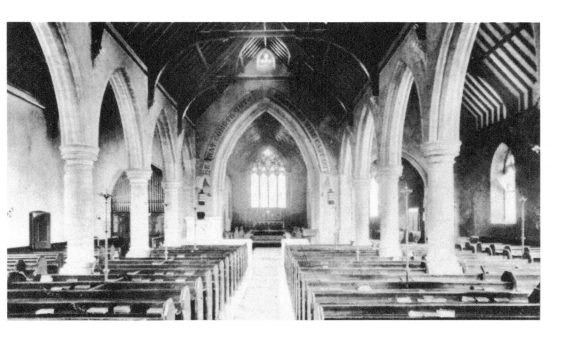

St David's Church Interior

The 2017 photograph of the nave shows it to have changed very little since the earlier photograph was taken in 1890. The pews have given way to comfortable and practical seats, while a screen that for many decades separated the chancel and nave has in recent years been resited to the side chapel.

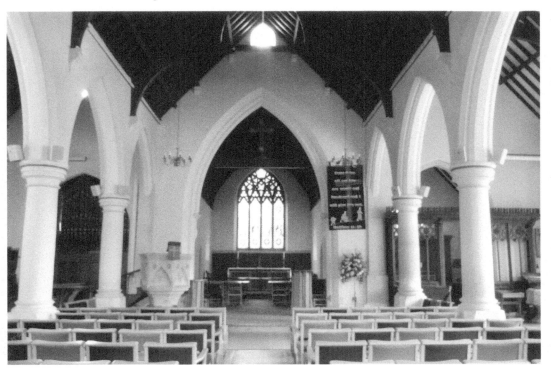

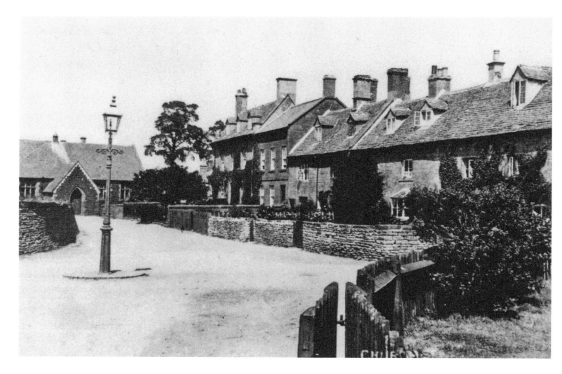

Church Street

Taken around 1915–20, this is a view looking towards the national school, whose headmaster was at that time Frank 'Togo' Harrison. It later became a secondary modern, until in 1965 pupils attended secondary education at Chipping Campden. A youth centre for some years, the building is now a church community hall called the St David's Centre. A bee apiary and a hurdle maker were situated on ground to the right of the picture. Southend Row cottages stood nearby.

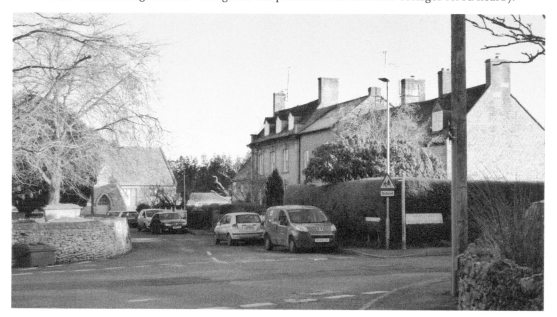

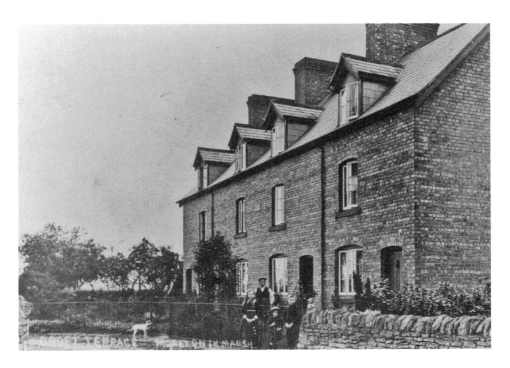

Croft Terrace, Old Town

By 1875 a branch of the International Order of Oddfellows had formed in Moreton and built around sixty houses – including Croft Terrace in 1908 – in the town during the late nineteenth and early twentieth centuries. For many years a coal merchant's yard existed near the south end of the terrace, although this closed in the 1990s. In 1941 a German aircraft dropped incendiary bombs on Moreton, a few landing (without causing damage) near Croft Terrace.

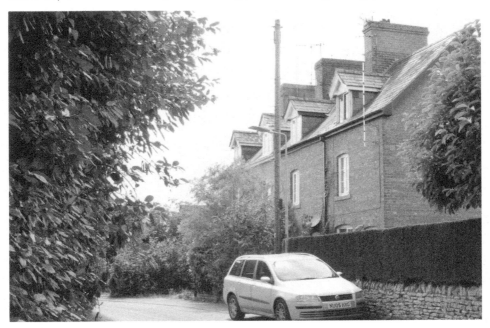

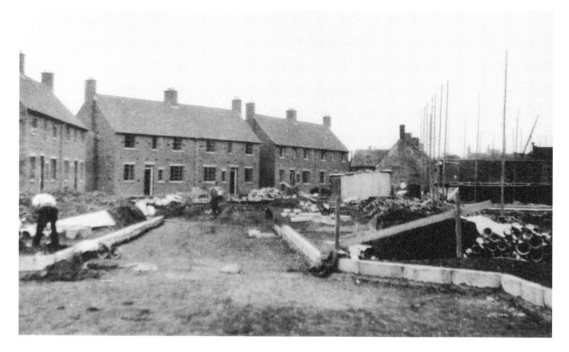

Building Warneford Place

This small housing estate, built around 1932, is named after Samuel Warneford, who was a wealthy nineteenth-century philanthropist and rector at Bourton-on-the-Hill. The building of Moreton Infants' School stands among his other acts of benevolence to the town. The railway line runs very close to Warneford Place, and during the Second World War, German and Italian prisoners of war often disembarked at a siding there before being marched to a camp at Bourton-on-the-Hill.

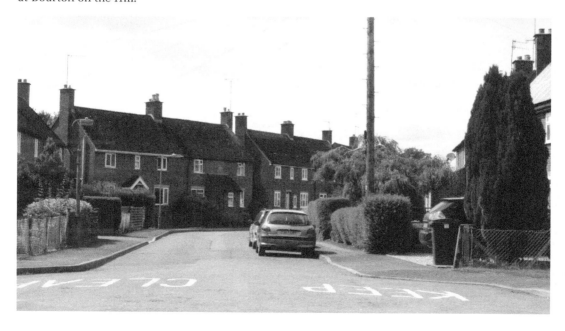

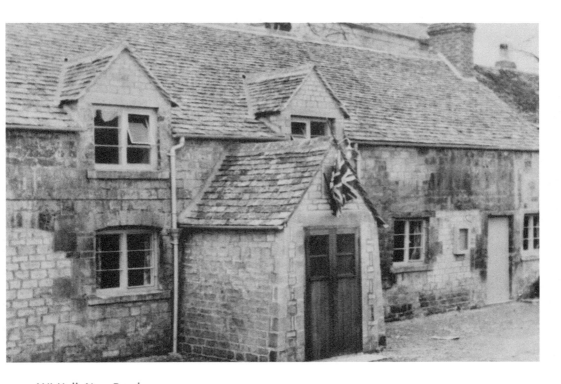

WI Hall, New Road
Originally a small terrace of three or four dilapidated cottages, the row was converted to a Women's Institute hall in 1954, this photograph being taken soon after its completion. A gathering of sixteen notable ladies were at the opening ceremony, with well-known local surnames including Barkes, Currill, Drury, Gray, Horne, Norledge and Tarplett.

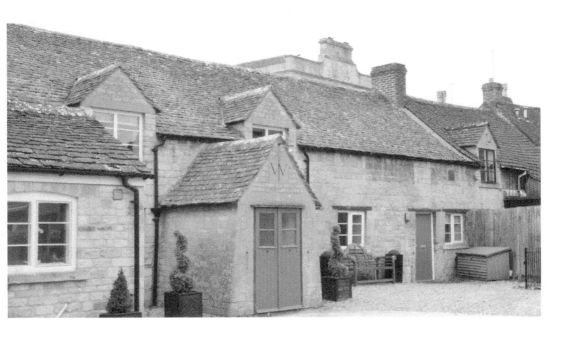

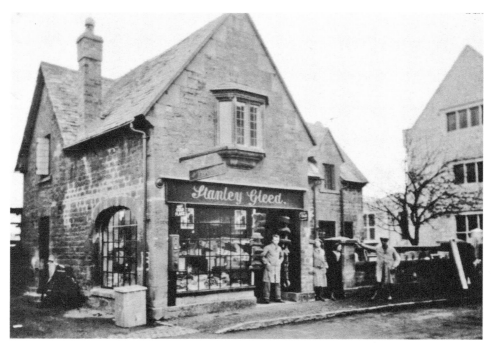

Gleed's Seed Merchant's Shop, New Road

Stanley Gleed's seed merchant's shop photographed around 1935. Kelly's Directory for 1939 shows the business to be owned by Mrs Lilian Gleed. By the early 1950s the shop was owned by Owen Kraft, who was also a seed merchant. The building became a laundrette in 1971.

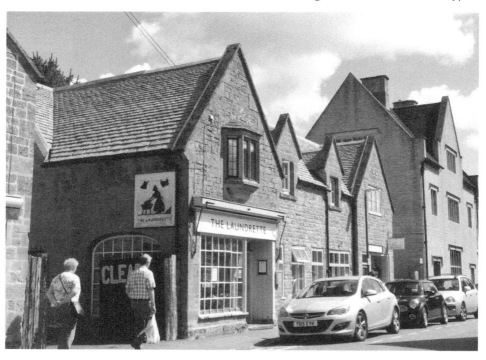

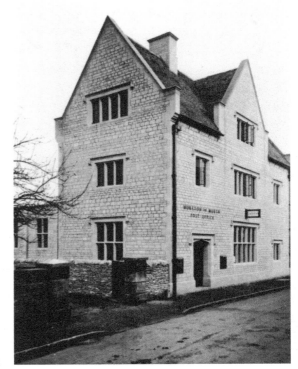

The Post Office

Moreton's original post office was situated in the High Street, next to the Bell Inn, at what is now the Katharine House Hospice charity shop. This photograph of 1933 shows the new post office that was built at New Road in that year. It was opened by Moreton's most distinguished son, Viscount Sankey, who was a High Court judge and, subsequently, Lord Chancellor in the 1929 Labour government. The post office moved to Budgens supermarket in 2013.

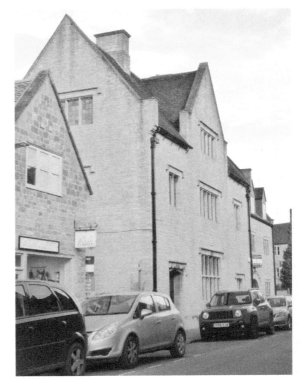

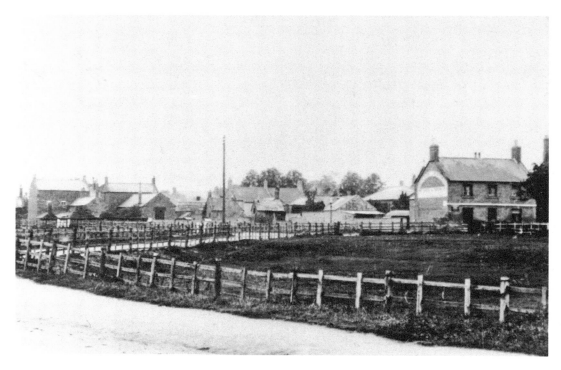

Station Approach

This 1905 photograph shows the ground beside the approach road to Moreton railway station. The uneven field in the foreground was known as 'Hicks's Paddock', where John Hicks, landlord of the Railway Inn – seen in the background – kept a donkey. A new British Legion club was built there in 1933. Station Garage was situated at the paddock on the left from around 1954.

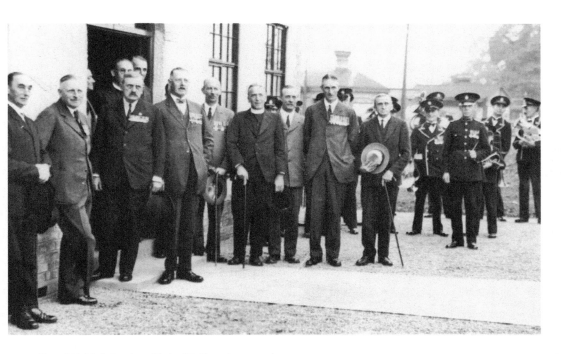

Royal British Legion Club, Station Approach
In 1918 an Old Comrades Association was formed at the Crown Inn and in 1920 a former army hut was erected in Station Road as a clubhouse. In 1933 a handsome new club was built nearby, subsequently being enjoyed by many ex-service personnel and other community members. To the regret of many, however, the club closed in 2008 and a decade later remains a gradually crumbling eyesore.

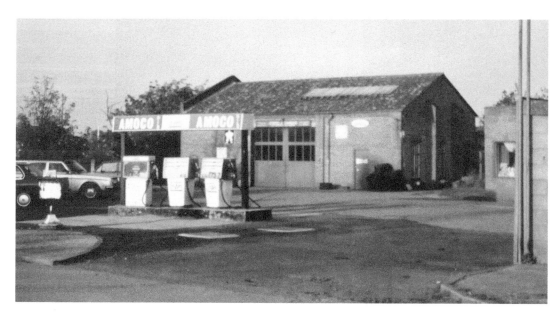

Station Garage, Station Road

Seen here in 1988, the garage was in 1954 owned by Bill Fry, who had previously operated from a yard at the Bell Inn, and in 1962 it was purchased by Frank Simmons. He ran it with his son, Martin, until the late 1980s, when it was the last garage in Moreton where vehicles would be manually refuelled by the proprietor. It finally closed in 2005, with Coachmans Court being built upon the ground in 2006–07.

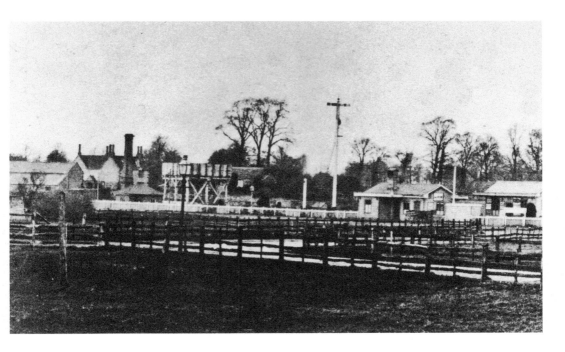

Railway Station

Moreton's first railway station, photographed here in the 1860s, was a wooden building that existed until 1872. The line opened through Moreton in 1853 as part of the Oxford, Worcester & Wolverhampton Railway, the station being one of their standard structures. On the left is a long stone building believed to be a saw mill, with Blenheim Farm behind. The line was absorbed into the Great Western Railway network in 1863.

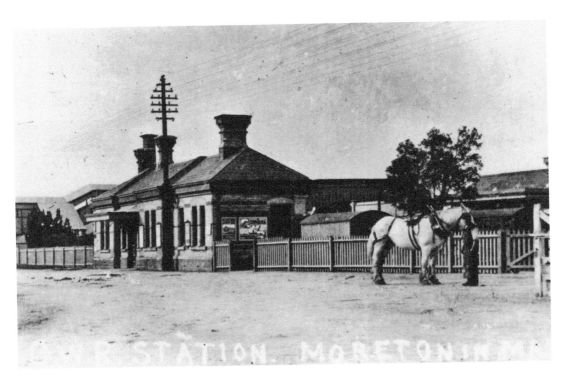

Railway Station

This view, dating to around 1910–12, shows the station building of 1872–73, with the covered footbridge to the left. This footbridge was dismantled about 1965–66 and was replaced by an open metal bridge. During the redoubling of the line in 2011 this bridge, too, was replaced, when a much larger structure – permitting safe disabled-access across the line – was installed. The chimneys were removed in the 1970s, giving the building a somewhat stunted appearance.

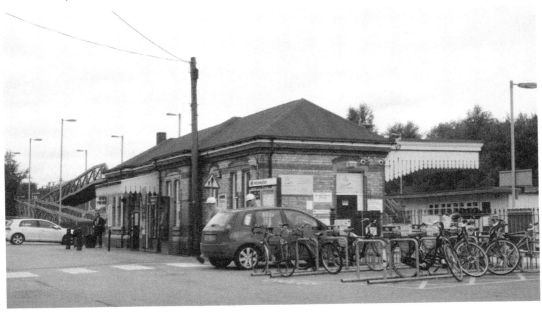

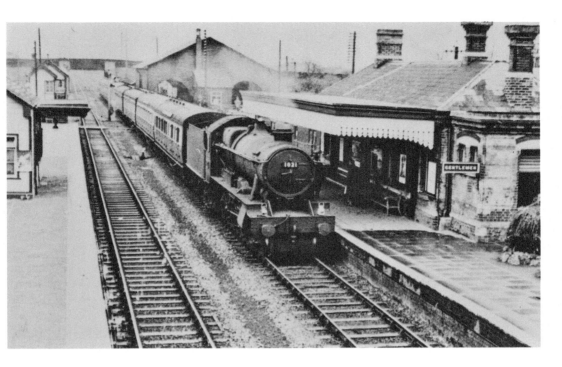

Steam Train at the Railway Station

A steam train arrives at Moreton railway station in 1954, en route to Worcester. This involved passing through the Gloucestershire stations of Blockley and Chipping Campden, both of which were to close in 1966. The waiting room on the left (up) platform is older than the station building, being a survival of the original wooden station that preceded the 1872–73 building.

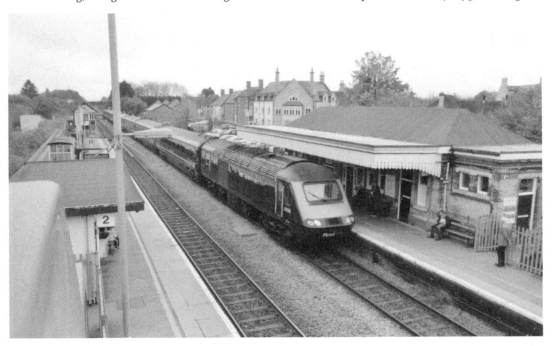

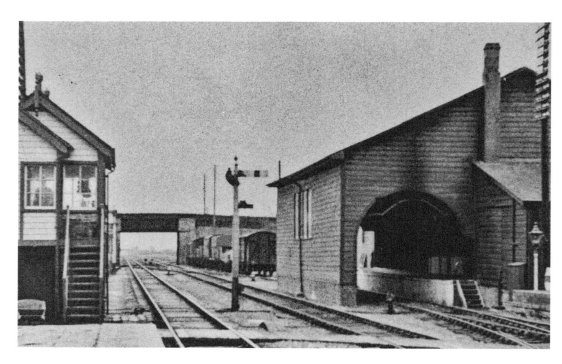

Signal Box and Goods Shed

The signal box and large wooden goods shed in 1954. The signal box, believed to date to the 1880s, continues in use, but the goods shed has long been dismantled, with only the much smaller brick building remaining. Until the 1960s all manner of goods were unloaded at the goods shed and adjacent yard to be loaded onto vehicles or horse-drawn waggons.

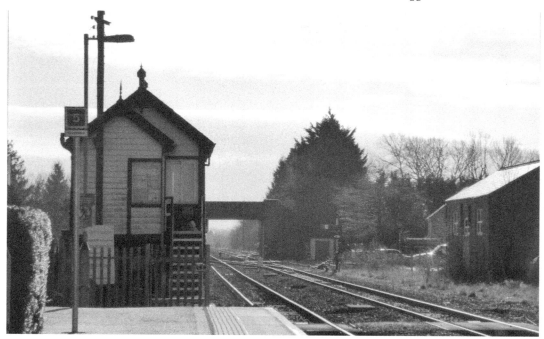

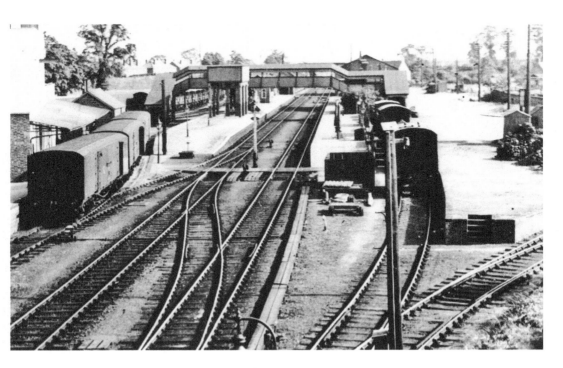

The Railway Looking East

This 1937 photograph shows the railway station yard, now built upon by Budgens supermarket and its customer car park. The sidings leading onto the yard and the dairy loading bay opposite were taken up some decades ago. The covered footbridge over the line is clearly visible to the west of the station.

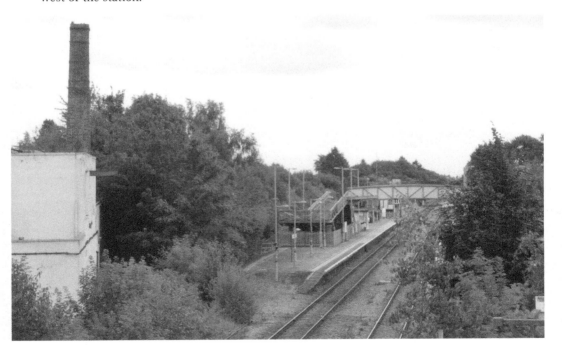

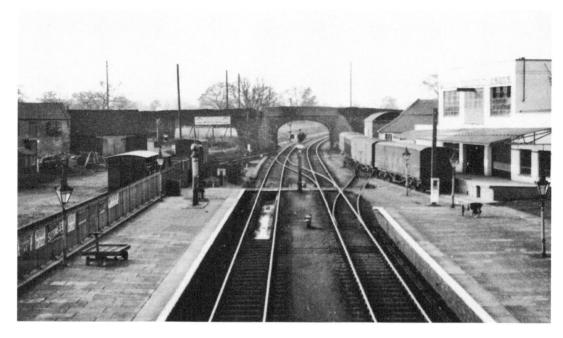

The Railway Looking West

A view from the station towards the Shipston Bridge in the 1930s. The stone building on the left – demolished decades ago – is a warehouse connected with the horse-drawn tramway that was opened from Moreton-in-Marsh to Stratford-upon-Avon in 1826. A branch to Shipston followed in 1836. The building on the right is the Dairy, which ran a large business connected with the supply of eggs and milk from around 1889 to its closure in 1973.

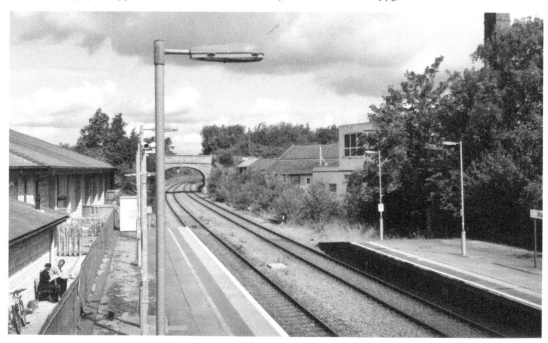

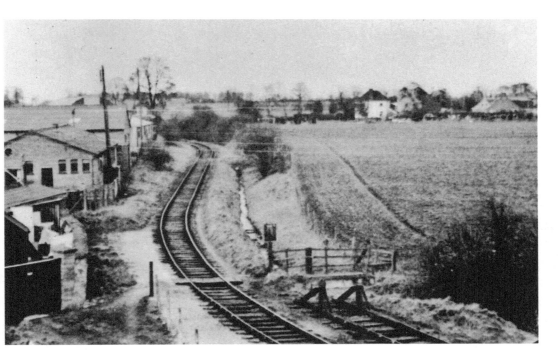

Branch Line to Shipston-on-Stour

The disused branch line from Moreton to Shipston in 1972. Moreton's main line opened in 1853, with the Great Western Railway relaying the old tramway line in 1886 for use by locomotives. The steam line to Shipston opened in 1889, but passenger numbers dwindled and the service ceased in 1929. A goods service continued until the line was finally closed in 1960. The 1990 photograph shows the changing view, which is now completely obscured by vegetation.

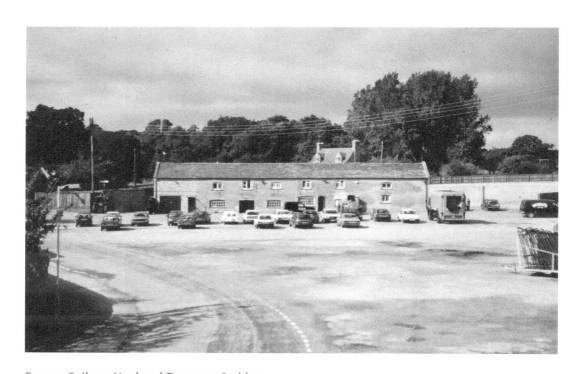

Former Railway Yard and Tramway Stables

A 1988 photograph of the stone building originally built as warehousing and stables for the 1826 Moreton to Stratford tramway. In 1988 it was used as offices by the Spook Erection market stall erection company, and it was without doubt among the oldest railway buildings in the country. Even so, it was demolished in 1989 to make way for a supermarket car park.

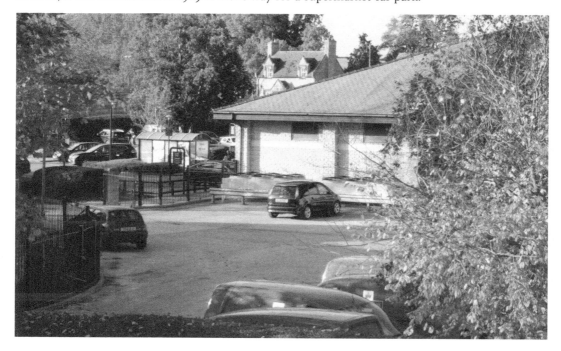

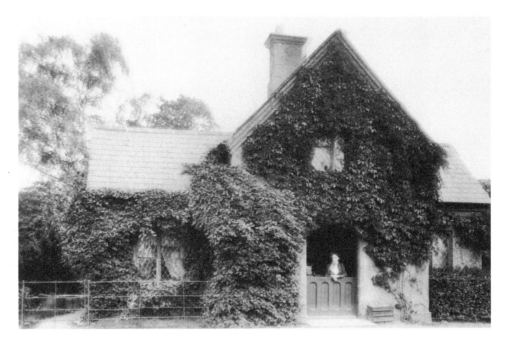

Gatehouse Lodge, London Road

London Road was turnpiked in 1731, although the lodge dates to the nineteenth century. The stable door in this photograph of around 1900 was used to serve customers purchasing the confectionery and tobacco sold there. Once occupied by an Albert Dyer, in the early years of the twentieth century it was run by an elderly lady who made her own brandy balls and humbugs. It closed in the late 1960s when run by Miss Sallis.

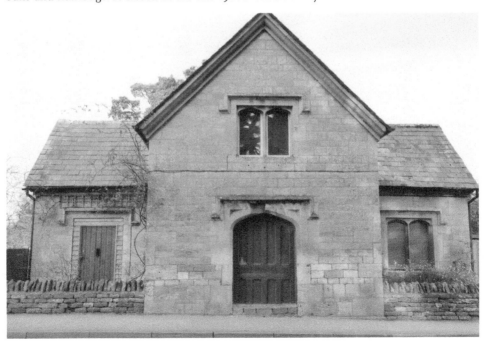

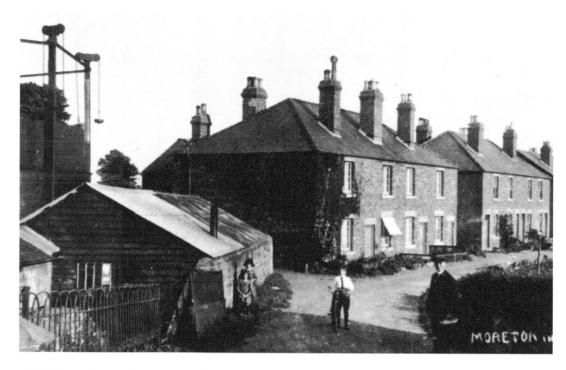

Oddfellows Terrace, London Road

Two of the terraced rows of Oddfellows houses, built 1877, with the gasworks to the left, photographed around 1920. The gasworks was built in 1846 and closed in 1958, with the gasholder standing empty until its demolition in the winter of 1962–63. Many local people believed that inhalation of the gas was beneficial to the respiratory system and children with bronchial illness were commonly taken there to breathe the fumes.

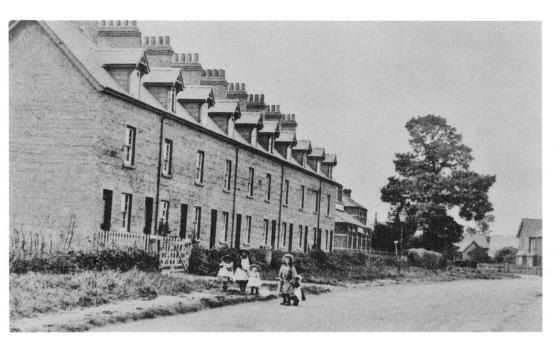

Cicester Terrace, London Road

Most of the new housing in Moreton during the late nineteenth and early twentieth century was built by the International Order of Oddfellows. Their Cicester Terrace, photographed here in 1917, was built in 1909. Buildings close to the right end of the row are part of a steam laundry set up around 1899 and later purchased by Paragon Laundry. The laundry burnt down in 1995, with private housing subsequently being built on the site.

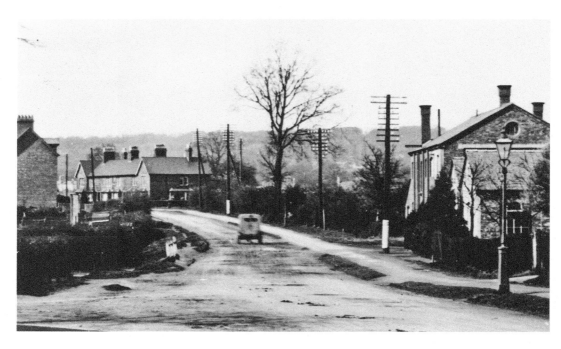

London Road Looking West

Pye's iron foundry photographed in the 1920s, with a pond bordered by a white fence situated opposite. The Victorian age Mitford Villas are at the roadside on the far right. London Road council houses were built on the rough ground bearing the hedge and tree around 1935. The pool was filled-in during the late 1940s or early 1950s to facilitate the building of London Road Garage (demolished in the 1990s).

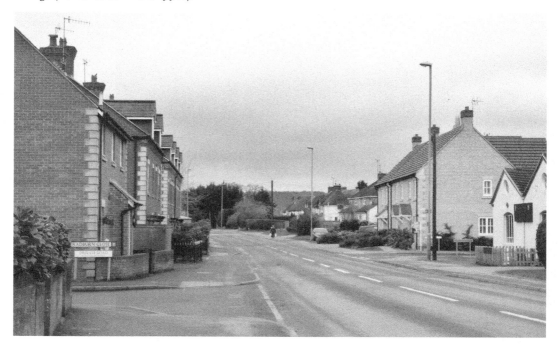

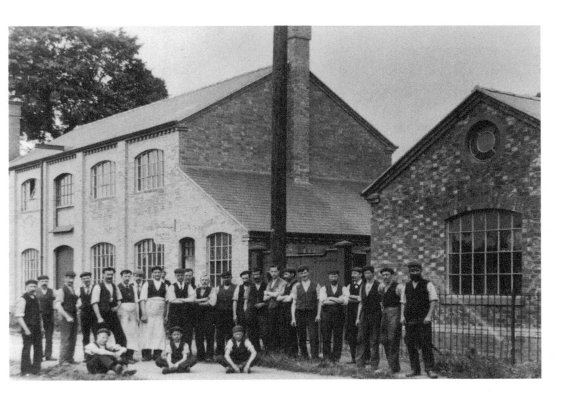

John Pye's Britannia Works

The Britannia Works, which began as a small iron foundry on the railway wharf, had by the late nineteenth century moved to a larger site on London Road. Given over almost entirely to the production of iron window casements, it became the town's largest industry. It later became a needle-making works until, in the 1940s, it was used for milking-machine manufacture. In 2012 the building was demolished and replaced with modern housing.

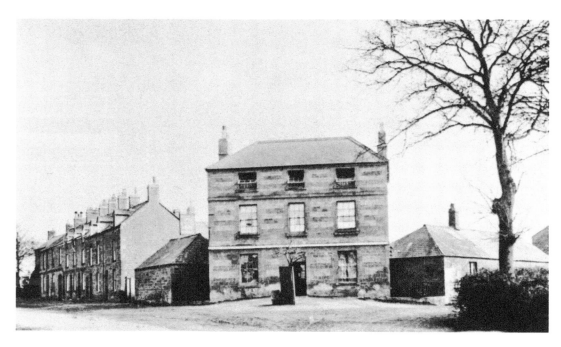

The Wellington Inn, London Road

Probably built around 1830–50, the Wellington – photographed in the 1890s when William Poole was the licensee – was much used by personnel from the nearby aerodrome in the 1940s. Quoits were regularly played on a nearby patch of ground in the 1920s, until AWH Engineering was built upon it in 1936 (subsequently closing down in 1987). Radburn Close, on the right, was built around 1995. The Wellington Inn closed in 2010 and was converted into flats.

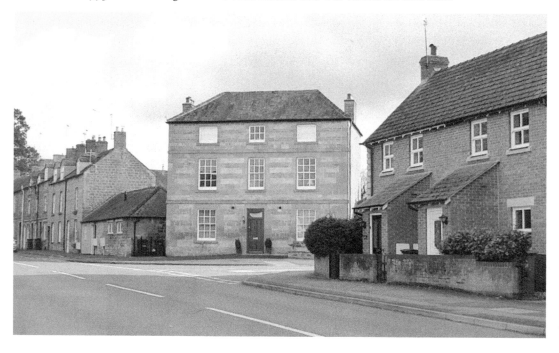

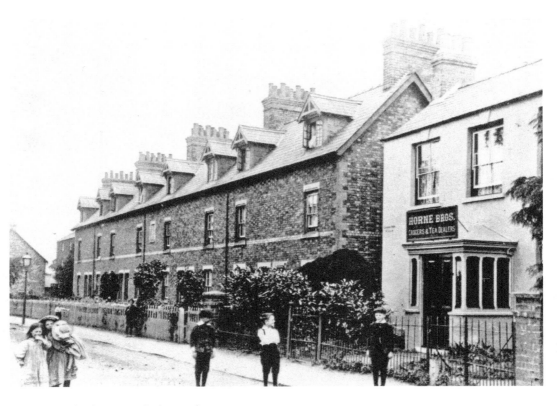

Horne's Shop, Evenlode Road

Charlton Terrace was built by the International Order of Oddfellows in 1887 and follows the usual pattern of simple brick-built terraced homes. This photograph, taken around 1915–20, shows the adjacent Horne Brothers' general provision shop, which closed in the 1960s. At London Road Terrace, in the same general area, a café and small shop traded in the 1950s and 1960s.

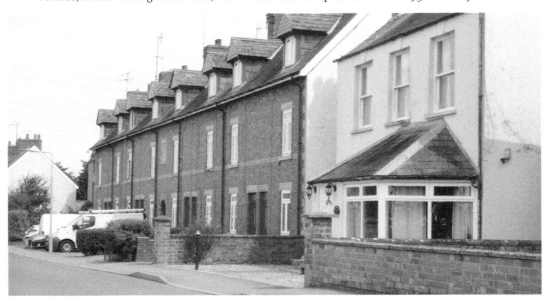

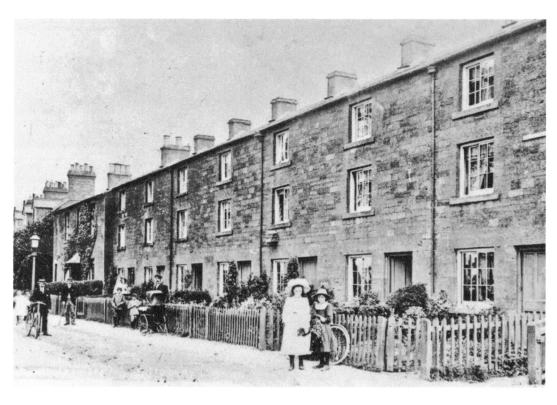

Wellington Terrace, Evenlode Road

A 1917 photograph of Wellington Terrace, which was built in 1860. In 1875 a school for boys and girls was founded at Wellington House, next to the north end of the terrace. It remained there until the mid-1930s, later moving to the Dormer House PNEU School in the High Street.

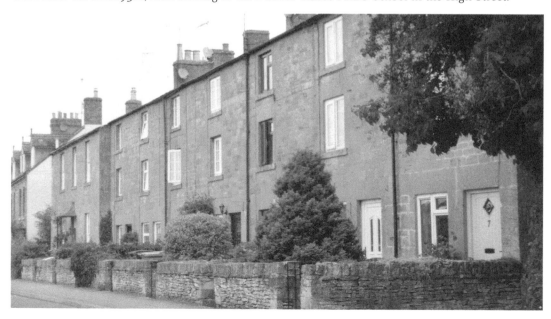

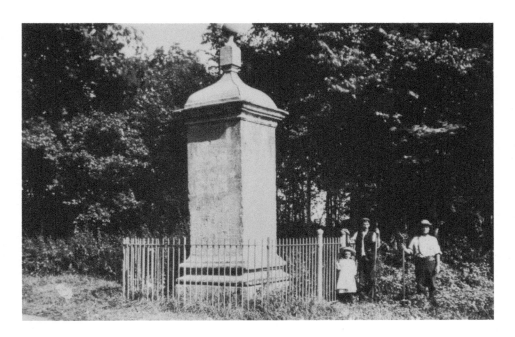

The Four Shire Stone

The 'detached' Worcestershire parish of Evenlode was transferred to Gloucestershire in boundary changes of 1931. Photographed around 1910, the eighteenth-century stone – with older origins – was expertly rebuilt around 1955 after it was severely damaged in a traffic accident. Tragically, a collision between a small plane and a glider occurred in the sky above the stone in 1990. Although the plane landed safely, the stricken glider plummeted into a field near the stone, killing the two occupants.

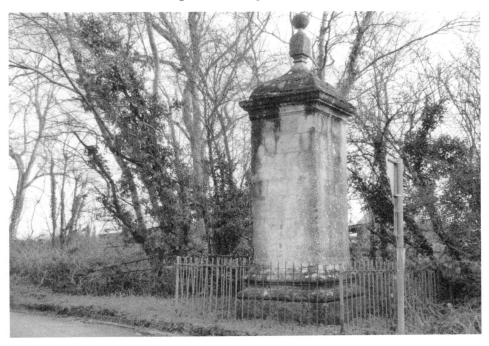

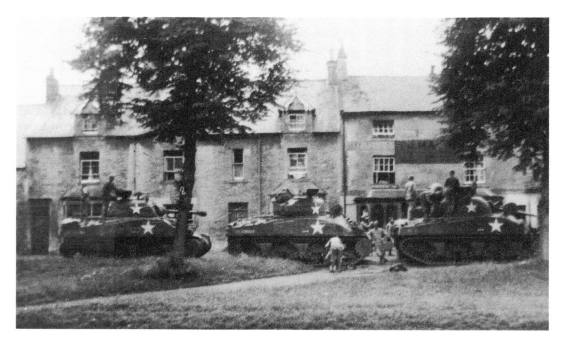

US Tanks, High Street Service Road
Moreton saw military activity in the Second World War, with an aerodrome for the training of Wellington bomber crews sited on the eastern edge of the town and men of the US Army's 6th Armored Division – known as the super-sixth – stationed in and around Moreton in the latter stages of the war. In this 1944 photograph Sherman tanks are seen in the town centre before embarkation to Normandy for the D-Day landings.

Also available from Amberley Publishing

Historic England

Gloucester

UNIQUE IMAGES FROM THE
ARCHIVES OF HISTORIC ENGLAND

An illustrated history of one of Britain's finest cities – Gloucester –
using photographs taken from the unique Historic England Archive.

9781 4456 8332 4

Available to order direct 01453 847 800

www.amberley-books.com